from LAND and SEA

NOVA SCOTIA'S CONTEMPORARY
LANDSCAPE ARTISTS

Edited by **DEE APPLEBY**

NIMBUS
PUBLISHING

Nimbus Publishing Limited
PO Box 9166, Halifax, NS B3K 5M8
(902) 455-4286 www.nimbus.ca

Printed and bound in Canada

Design: Troy Cole, Envision Graphic Design
Front cover: *Between Houses* by Steven Rhude, photographed for reproduction by Gary Woodcock
Back cover: *Bridge in Wet Fog* by Paul Hannon, oil on canvas, 2003
Author photo: Bob Pridham

Library and Archives Canada Cataloguing in Publication

From land and sea : Nova Scotia's contemporary
landscape artists / [edited by] Dee Appleby.
ISBN 978-1-55109-729-9

1. Nova Scotia—In art. 2. Landscape in art.
3. Artists—Nova Scotia—Biography. 4. Art, Canadian—
Nova Scotia—21st century. I. Appleby, Dee

ND1352.C37F76 2009 704.9'4367160922 C2009-902864-6

We acknowledge the financial support of the Government of Canada through the Book Publishing Industry Development Program (BPIDP) and the Canada Council, and of the Province of Nova Scotia through the Department of Tourism, Culture and Heritage for our publishing activities.

Dedication

A chance visit to Alice Reed's studio in Pomquet led me to learn of the Nova Scotia Nature Trust and its work. This book is dedicated to the volunteers and staff of the NSNT, whose unwavering belief in the conservation of Nova Scotia wilderness areas will continue to ensure that our children have the privilege of discovering the timeless beauty of our natural world.

To Brian, Jennie, and Christina
And in memory of my mother, Alice Elizabeth MacKay Jutras

Table of Contents

Foreword

Throughout the modern era landscape has risen and fallen in critical esteem, sometimes the height of artistic fashion, sometimes an out-and-out pariah. Derided as conservative, or lauded as poetic and awe-inspiring, perhaps the only constant has been the desire of artists to depict the world as they find it, and the desire and willingness of audiences to let these artists show them new ways to see the world.

The artists whose works and words have been collected in this book look at the landscape with intensity and open up new avenues for the viewers. They see things in a new way and, through their work, suggest ways that we, too, may see differently. When one looks at something constantly, the trick—and in fact, the skill—lies in seeing it regularly anew. To see, rather than to merely look, as Tom Forrestall would say. Too often when we look, we only see what we expect. Our habits of perception, as with other habits, make it easier to get by, but that ease comes with a price.

Landscape, as a genre, has long been a favoured one in Atlantic Canada, as Dee Appleby describes in her introductory text. The reasons for this are myriad, and I will leave it to the artists to describe their motivations.

But it is important to remember that despite the subject matter of these works, despite the so-called "realism" employed by so many of the artists, landscape painting, any landscape painting, is essentially a fiction.

After all, the works depicted in this book are constructions, representations of places real and imagined; what we call landscape is a human creation. Whether we paint it, photograph it, or simply marvel at it, a landscape is a human construct, a function of editing and of invention. Fundamentally, "the landscape" as such, does not exist: the map is not the territory.

Fictions, of course, are stories, and in a way, that is what these works are: stories about specific places, whether real or imagined, places that are altered in the re-telling, that reveal as much about the tellers as they do about the tales.

In this book, the editor and artists have created a compelling series of tales in words and images, and a compendium of places that one will want to visit again and again.

Ray Cronin
Director and Chief Executive Officer, Art Gallery of Nova Scotia
June 2009

Acknowledgements

I would like to thank, first of all, Patrick Murphy, senior editor at Nimbus, for supporting this project, and Heather Bryan for her technical expertise in handling the hundreds of images. Many thanks to all the artists who contributed the images of their work. My deepest gratitude to Pierre and Agnès Jutras; Fred and Elizabeth Fountain for their support; Ray Cronin, director of the Art Gallery of Nova Scotia; Craig Yorke at Image House for his expertise and countless hours spent scanning dozens of paintings; Peter Kirby and Peter Guildford, Department of Heritage, Tourism, and Culture; Paul O'Keefe, for helping sift through the hundreds of images; my gallery tour crew— photographer Jinx MacGillivray, Beth Johnston, and Lorraine Day, who visited countless galleries with me; Adriana Afford, Argyle Fine Art, Halifax; Peter Dykhuis, curator, Dalhousie Art Gallery; Robin Metcalfe, curator, St. Mary's University Art Gallery; Andrew Terris, Arts Nova; Ron Joyce for providing the space for my gallery at Fox Harb'r Resort; and finally, to my husband, Brian, without whose support this book could not have been published, and my daughters, Jennie and Christina. My apologies to the landscape artists that could not be included for lack of space or any galleries I may have overlooked.

Sponsors:
Fred and Elizabeth Fountain
Brian and Dee Appleby

Introduction

Nova Scotia is illuminated with a distinctive and ever-changing light. A near-island bathed in salty sea air, brushed by steady winds, our landscape can be shadowed by dark clouds one moment, lit by a brilliant summer sun the next. Our weather drapes the landscape in a delicate veil and gives it texture, changing constantly through the hours of the day and seasons of the year.

The raw beauty of our varied landscape is sometimes forgotten by those who live here. It takes an artist's eye to show us. Here the artist finds the mental space needed to create, which perhaps explains the predominance of the landscape as a subject in Nova Scotia art. Scarlet clouds bursting above a reckless sea. Golden fields of cut hay dusted with an early snow. Ancient forests of giant hemlock. Lurid shadows of purple and blue along a rocky shore. "Nova Scotia is more about place than opportunity," explains one artist. For watercolourist Kathy Brown, who had been drawing and painting all her life, "it took a move to Nova Scotia for me to find my place." Cluny Maher, who arrived in 1977 from the Beauce region of Québec, explains, "Nova Scotia is an ideal place for landscape painting. The quality of light is so subdued, with micro weather systems that give us a different scene around every corner."

For many artists the landscape that defines us is not merely beneath our feet, but in our minds—a sense of place and infinite space. In the words of Caspar David Friedrich, "The artist should not only paint what he sees before him, but what he sees within him." Several artists asked me to "define landscape" when selecting images for this book. Initially, my thoughts on the subject were very clear: a classical approach to landscape, depicting our rugged coastline and wilderness areas in the Realist tradition. A conversation with Robin Metcalfe, curator at St. Mary's University Art Gallery, however, convinced me that a much broader definition was needed—one that included, for example, an aerial view, as in the case of former recreational pilot Peter Dykhuis, now director/curator of the Dalhousie Art Gallery. For conceptualist Wayne Boucher, landscape incorporates the watery underworld that surrounds us, his canvas saturated with vivid, luminous colour.

The term "landscape" soon evolved into much more—something very personal and intangible, based on one's own perceptions and experiences. For Dozay Christmas of Cape Breton, it is the landmarks immortalized in ancient legends. For Bruce Wood of Truro, it is fly-fishing on the West River at dawn on an autumn morning. For Paul Hannon of Halifax, it is cloud shadows, sunlit fields, and winding country roads. David Lacey of Hall's Harbour uses brilliant hues and thick brush strokes to interpret his vision of land, sea, and sky. In his Ancient Landscape series, Don Pentz paints "landscapes of the imagination, suggested by the working of paint into the textured canvas surface, but influenced by the natural world of shoreline rock or inland barren."

In the end, the style the artist chooses is not at issue here, but rather how they interpret and communicate the world around them. Cape Breton artist Doug Fraser attempts this by capturing the mood: "My goal is to create luminous skies, misty atmospheres, and…an evocative feeling in each piece. To give us the impression of a particular moment in time,

of a particular mood, to make us aware of the awe of this privileged moment."

Light and how it illuminates the landscape is the inspiration for this book. The function of light in nature is so pervasive that we often overlook the effect it has on our *impressions* of a scene and the extent to which it reveals form. In the history of art, this came to be known as the "emotionalization of nature" beginning with the work of J. M. W. Turner (1775–1851), known as "the painter of light." Impressionist Edouard Manet (1832–1883) declared that the chief actor in painting is light, while what it reveals becomes purely incidental. The Impressionists broke from tradition and painted scenes of simple, everyday life, rejecting the heroic and religious themes that dominated the art world until their appearance in the 1870s. Often working *en plein air* to maintain a sense of freshness in their work, landscape for them was a theme sufficient unto itself. In casting aside the studio tradition and painting outdoors, the Impressionists were able to capture on canvas the changing effects of light. They cultivated the technique of blurring their figures to produce the effect of floating light, employing muted tones and hazy outlines to create a strong sense of mood. Mark Brennan

is a prime example of our *plein air* artists; he camps for days in the wilderness in order to create that spontaneity so reminiscent of the Impressionists, suggesting a landscape that is untamed and constantly changing with the light. Through the art of realists such as Leonard Paul, Tom Forrestall, J. William Johnson, Alice Reed, and Alan Bateman, we are immersed in a rare moment frozen in time.

The works covered in this book represent a wide range of artistic styles prevalent in Nova Scotia landscape art today. Which style dominates over another is a matter of conjecture. According to Mora Dianne O'Neill in *Paintings of Nova Scotia*, the majority of contemporary Nova Scotia painters "employ a very personal, and generally romantic, expressionism that defies categories." Mostly, it is a feeling they wish to convey, an emotional connection with the land that stirs their passion to paint.

Often, inspiration is drawn from a deep-rooted tradition of storytelling, as in the Glooscap legends of Dozay Christmas and Alan Syliboy; or from everyday life on a farm near Canning, as is the case in the work of Alan Bateman. For Acadian artist June Deveau, the inspiration for her work stems from a rich cultural tradition, depicting

the everyday lives of her ancestors on St. Mary's Bay, along the French Shore. Steven Rhude's work has engendered a new term, poetic realism, where ordinary objects meet extraordinary situations with a touch of humour and political satire, as in his painting of dories on a clothesline called *Hung Out to Dry*. His message goes beyond portrayal of the landscape to social consciousness, depicting the decline of the fishery and a traditional Maritime way of life. With Gordon Macdonald's landscapes, reminiscent of the nineteenth-century American luminous tradition, we discover the flawless beauty of the mountains, lakes, marshlands, and rivers of our region, with Gaelic titles such as *Chunnic mi Nan Goabhau*, or *I saw the trees*. In summary, each artist approaches his or her work with a different eye, a different mindset, but always with the deepest respect and passion for this land.

The influence of the Group of Seven on the country's conscience prevails to this day, symbolizing the idea of a distinctly Canadian identity. The Group's pride of place is shared by our own artists here in Nova Scotia, whose style of painting, in many cases, is shaped by the landscape itself. The seventy contemporary artists featured here are among

the finest in the province—"contemporary" meaning living artists as of the publication of this book. Seventy is, obviously, not a magic number, but rather the maximum we could accommodate in a project of this nature; this ruled out the inclusion of a great number of excellent painters. Tom Smart, executive director and chief executive officer of the McMichael Canadian Art Collection in Kleinburg, Ontario, said in a recent Canadian Press article, "It's a funny thing about Atlantic Canada…there are just raw veins of extraordinary artistic talent that need to be explored." This book is just the tip of the iceberg. We attempted to represent all regions of the province in one volume; as a result only about one-third of all professional landscape artists could be featured.

The criteria for the selection of artists were simple: they must be permanent residents of Nova Scotia, professional artists that paint mainly Nova Scotia landscapes, and their work must be represented by commercial galleries. Many are graduates of NSCAD (the Nova Scotia College of Art and Design, now known as NSCAD University), the main driving force behind the arts scene in Nova Scotia. All are professional artists who have, against all odds, found creative ways to forge

a living in the bleak, often hostile landscape of the arts. It is indeed the road less travelled.

Artists working in Nova Scotia today are not only talented, but highly resourceful. Often they work in relative seclusion in a market that shifts with the seasons and guarantees little in terms of a steady livelihood. In spite of this, artists are still among the most active volunteers in our communities. Some operate galleries that double as cafés or framing and art supply stores; they teach art in schools and community centres. They do not sit idly in their studios waiting for their next commission, or for tourists to beat a path to their door (though the teapot is waiting if they do). Often, they are their own agents, devoting as much time to marketing their work as creating it. They sit on the boards of arts councils and artist-run centres, and donate their works to local charities. They imagine the possibilities, not the roadblocks.

The existence of two world-class fine arts schools within the region, NSCAD in Halifax, and Mount Allison University in Sackville, New Brunswick, has had a profound and lasting affect on the growth of the arts in Nova Scotia. Attracting such acclaimed artists as Arthur Lismer, Alex Colville, Alice Reed,

and Garry Neill Kennedy to our shores has increased the calibre of art instruction in this area. In the seventies, NSCAD was touted as the best art school in North America, and it is still numbered among the best in North America to this day.

The history of NSCAD is inseparable from the history of art in Nova Scotia. In 1988, Bernie Riordon, former director of the Art Gallery of Nova Scotia, said "The college has played a very important role in the cultural life of Nova Scotia and Canada, and has clearly been the focus for art development of the province." NSCAD began in 1887 as the Victoria School of Art and Design, with Anna Leonowens among its founders. For the next hundred years, the story of NSCAD includes the quest for suitable space, the struggle to survive with limited resources, the relationship between the school and the local community, national and international influences, the role of women, and shifting leadership styles. For twenty years after Garry Neill Kennedy became NSCAD's new president in 1968, it assumed a more assertive role, embracing the trends that marked the end of conventional art forms such as still life, landscape, and marine painting, which until then had determined the state of painting in

Nova Scotia. The "Kennedy Régime" sought to bring "relevance" to the art produced by its students, encouraging them to approach their art forms with a more contemporary perspective. To this day, NSCAD students continue to produce some of the most innovative works found in the art world today, from canvas to clay, textile, jewellery, and design.

The main spinoff of NSCAD has been the establishment of a professional arts community, and with it, a whole new market for art consumption. As NSCAD University expands into the twenty-first century and its new seventy-thousand-square-foot, fourteen-million-dollar waterfront campus, it will continue to be the driving force behind the arts in Nova Scotia. Through the university's expansion program, its board of governors wants to ensure that creative talent will play a much larger role in Atlantic Canada's new enterprise and economic development.

The evolution of the arts in Nova Scotia has always been contingent on four factors: immigration of talent, creation of institutions, nurturing of intellectual interest in the arts, and economic prosperity. Like a garden, the arts can only flourish in favourable conditions, often in the form of enlightened patronage, such as the Sobey Art Award, the Portia White Prize, and the Lieutenant Governor's Masterworks Arts Award. Though many of our artists have achieved international acclaim for their work our demographics are such that, without financial support in the form of scholarships, awards, donations, and grants to assist in its creation and dissemination, the freedom to engage in artistic pursuits would be severely challenged. But the world has started to take notice. According to Robert C. Hain, member of NSCAD's board of governors and an avid collector of Atlantic Canadian art, "Though Nova Scotians never thought of themselves as particularly competitive in the art world, they certainly are now. It's going through one of those flowerings right now…But the nature of Nova Scotians is not to blow their own horn, unless they're in a band."

In each region, our artists have made a name for themselves locally, nationally, and internationally, often attracting other artists to the area and contributing to the local economy. The Annapolis Region Community Arts Council (ARCAC), co-founded by artist Wayne Boucher in 1982, stands out among community arts councils in finding creative ways to share its members' work and ideas with one another and with the community at large. ARCAC has developed a reputation for breaking new ground in arts initiatives within the community, becoming one of the most vibrant grassroots arts organizations in the province, run by some 250 volunteers. Its signature event, Paint the Town, involves over eighty artists who paint, sketch, and sculpt at various venues around town. Generating over thirty thousand dollars in art sales, it has become the single most important revenue generating event of the year for Annapolis Royal.

In Halifax, artist-run centres such as the Khyber, and other grassroots initiatives, such as Queen Street Studios in Dartmouth, are thriving. The Gallery at Creative Crossing is one of the most innovative visual arts venues to date. A revitalized post-industrial complex, it offers multi-use spaces and artist studios designed to encourage collaboration among resident artists.

According to a study of artists in large Canadian cities conducted by Hill Strategies Research in 2006, there are 3,510 working artists in Nova Scotia; the term "artist" refers to actors, photographers, writers, painters, dancers, musicians, composers, singers, producers, etc. This number represents 0.7 percent of the total labour force. Of that

number, 57 percent reside in Halifax; 165 of those are painters, sculptors, and other visual artists. According to the Halifax Art Map 2008, there are eighty-four artist studios, galleries, and art-related supply shops in the Halifax Regional Municipality. Curator Robin Metcalfe states, "The number of galleries and visual artists in the city is way out of proportion to the population of the city. If I go to New York City or Berlin, people know of Halifax, they've heard of our artists. Sometimes I think Halifax is a well-kept secret to Halifax."

In rural communities, the concentration of artists is higher than in the city, as in Victoria County, Cape Breton, where artists comprise 1.9 percent of the local labour force. One rural area in Nova Scotia, along the South Shore around La Have, has an artistic concentration that is more than double the national average, where artists represent 2.2 percent of the local labour force. This is the second highest artistic concentration of all rural postal areas in Canada, according to Hill Strategies Research's 2005 report on artists by neighbourhood in Canada. The report's key finding that there are higher concentrations of artists in rural communities, "demonstrates that the arts contribute to the quality of life and the social and economic vitality of many small and rural communities in

Canada…A strong artistic community can lead to 'pride of place' and can therefore enhance the whole community's well-being."

The South Shore boasts the highest concentration of rural galleries in the Atlantic Provinces, with eighteen galleries in the Lunenburg area alone (where the population in 2006 was 2,317). The Lunenburg Art Gallery now boasts eighty-five member artists. In a matter of a few generations, the town has transitioned from a faltering fishing community to a thriving artistic community. Bear River and Annapolis Royal have also established themselves as artists' meccas, with eleven artist studios in Bear River alone and a thriving artisan community throughout Digby County. Proof enough that artists can determine the fate of their communities as well as any other industry, with conservation and environmental issues coming to the forefront as a frequent spinoff.

Community arts councils, of which there are eleven, play an integral role in the life of the Nova Scotia arts community, bringing together artists, writers, photographers, sculptors, potters, etc. and organizing exhibits, concerts, writers' workshops, and art and music classes. With provincial funding through the Nova Scotia Department

of Tourism, Culture and Heritage, these organizations have contributed greatly to the revitalization and overall health and well-being of their communities, encouraging artists to remain in rural areas where they choose to live, close to the subjects they love most to paint.

Certain communities in Nova Scotia stand out because of the artists that live there and the ones "from away" that have moved there. Artists from other areas are settling in Nova Scotia, attracted by our landscape and quality of life, bringing with them enthusiasm and expertise and becoming driving forces in their adopted communities. Annapolis Royal, Shelburne, Antigonish, Truro, and Inverness, for example, have well-entrenched arts councils and well-focused arts communities. In areas such as the Eastern Shore and Hants, we see development beginning to percolate. Becoming a full-time artist is now a plausible choice due to a shift in artists' perceptions of themselves as valuable contributors to the new, creative economy.

Why should we support our artists? Simply put, they reflect who we are—our heritage, our culture, our landscape, our cities. They communicate a sense of place, explore the human condition, engage, challenge,

acknowledge, witness, and react to the culture they consciously or unconsciously mirror. Or, as Alex Colville puts it, "You spend your whole life telling people what it's like to be alive." Colville approaches life and its meaning by examining his surroundings: the Annapolis Valley, the shores of the Minas Basin, his home and his family. "Landscape…rises from the unconscious and roots us to a place," he explains in an interview on the television program, *Biography*. "It is my job as an artist to make order out of chaos, so that things that don't seem to make sense do make sense."

In compiling this book, I have had the distinct pleasure of meeting the best and brightest in the Nova Scotia visual arts scene today. Their enthusiasm and commitment to their craft is inspirational. This book is my attempt to return to both the artists, and the galleries that represent them, the respect and recognition they are due. If, in the process of publishing this book, I can convince Nova Scotians that collecting original Nova Scotian art—be it landscape or otherwise—is not only a sound investment, but guaranteed to provide a lifetime of enjoyment, I will have succeeded. By supporting our artists, we in turn help sustain the things that they hold dear—vibrant communities, conservation, and environmental responsibility. The effects on our culture and well-being are long-lasting and truly the greatest gifts we can give to the future.

From the Highlands of Cape Breton to the French Shore, the length and breadth of Nova Scotia is represented here. Many artists are Nova Scotian by birth, others by choice. But they all have this in common—a profound sense of place, a love of nature, and a desire to communicate that love and respect to others. For many, such as Alice Reed, honorary director of the Nova Scotia Nature Trust, landscape painting has assumed a new purpose —to raise public awareness of the need to conserve our natural heritage. "My experiences in wilderness inspire me to paint, to share the wonder and exquisite grace of nature. I hope my artwork will show how precious wilderness is and will instill in others a sense of respect for it and a willingness to act accordingly." In 1995, in collaboration with the Nova Scotia Nature Trust, Alice Reed and her husband, environmentalist Bob Bancroft, set out to explore and paint the thirty-one wilderness areas protected by the provincial government. The result was thirty-two extraordinary watercolour paintings of these areas, known as the Sacred Worth series.

Now more than ever before, landscape artists play a vital role in illustrating our natural heritage, preserving—if only on canvas—a fragile world hanging in the balance.

To Mark Brennan of Pictou County, I give the final word: "I see the landscape as something pure, containing age-old rhythms and patterns, and with each painting I seek this ebb and flow of nature that holds us all together, to form our connection to all things wild."

Dee Appleby
July 2009

Works Cited

Ash, Russell. The Impressionists and Their Art. London: Orbis, 1980.

"Eighty/Twenty." Art Gallery of Nova Scotia, 1988.

"Halifax Art Map 2008: A Guide to Studios and Galleries in Halifax Regional Municipality." www.halifaxartmap.ns.ca (accessed April 13, 2009).

Hill Strategies Research. "Artistic Small and Rural Municipalities in the Atlantic Provinces." 2005.

———. "Artists by Neighbourhood in Canada." 2005.

———. "Artists in Large Canadian Cities." 2006.

O'Neill, Mora Dianne. Paintings of Nova Scotia. Halifax: Nimbus, 2004.

Wallace, Kate, "The mind's eye," Telegraph Journal, January 10, 2009.

Artists

Frans Aeyelts was born in the Netherlands, where he received his formal education. He first studied graphic design, followed by industrial printing techniques and management. It was the fine arts that captured his imagination in the end, allowing him to express himself without restriction.

His other interest was the ocean, which led to employment with the Department of Fisheries and Oceans in Nova Scotia. This offered Aeyelts an opportunity to study various aspects of offshore sailing. Eventually he sailed his own home-built boat to the West Indies.

Aeyelts returned to drawing and painting, however, and gradually took on a teaching role, offering classes in drawing and watercolour techniques. His other art-related endeavours include conducting workshops and commission work (house, garden, and boat portraits).

I STRIVE TO INTERPRET THE VISUAL EMOTIONS EVOKED BY THE SURROUNDING WORLD to an artistic level through balanced composition, design, and colour values, culminating into a visually pleasing experience.

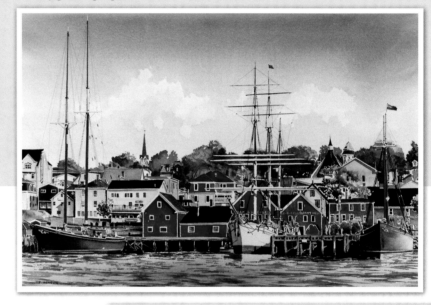

Lunenburg Waterfront
watercolour
14" x 21"

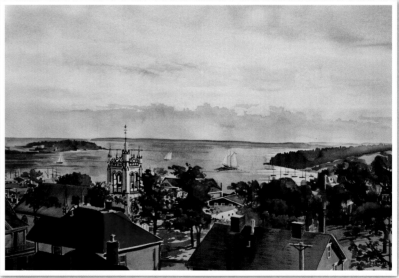

Rooftop view, Lunenburg watercolour—14" x 21"

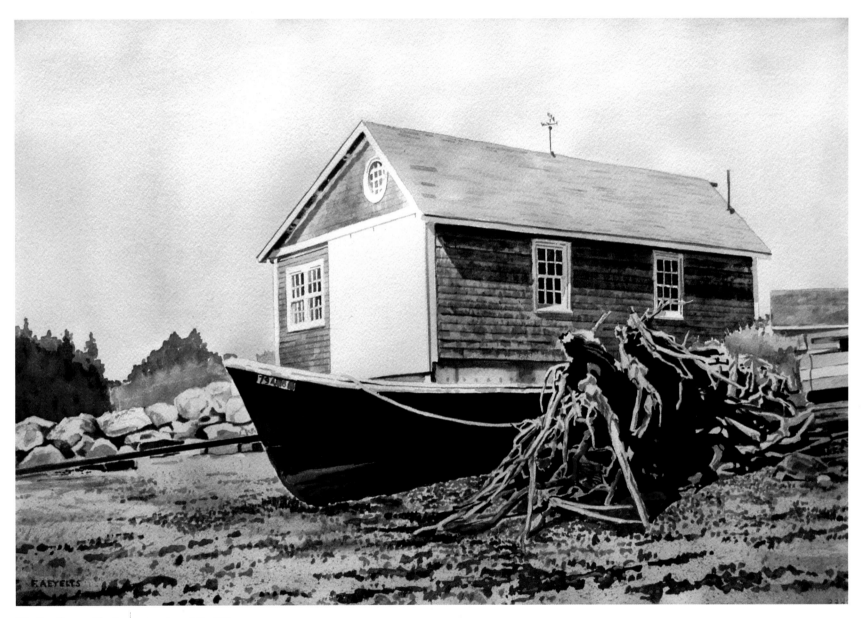

The Boathouse, Chester watercolour—14″ x 21″

Jeanne Aisthorpe-Smith had focused on a body of work that reflected a lifelong love of horses, but in January 1999, she turned her attention to landscapes. Working with fields of colour that resonate together is something she finds very exciting. Her landscape paintings juxtapose vibrant and arbitrary colour against traditional architecture, resulting in a feeling of harmony and joy. Aisthorpe-Smith occasionally creates still lifes, florals, and portraiture as an expression of her passion for painting. She has worked in many different mediums, but currently works with oils and acrylics. Her work has been influenced by Arthur Schilling, Nicholai Fechin, Ted Harrison, Jean Jacks, and Charlotte Beauchemin among others, and has been displayed at many North American galleries, including Secord Gallery in Halifax, Harvest Gallery in Wolfville, and Jo Beale Gallery in Peggy's Cove.

I CONSIDER MYSELF ONE OF THE FORTUNATE PEOPLE IN THE WORLD WHO GET TO DO WHAT THEY LOVE TO DO. I believe when that happens, work is no longer work, but joy expressing. Then we are in the wellspring of our true service and everything becomes a blessing to life.

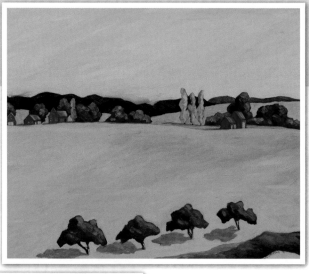

Golden Glow
oil on canvas
30" x 36"

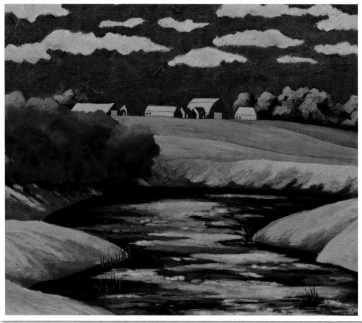

It's the River oil on canvas–20" x 24"

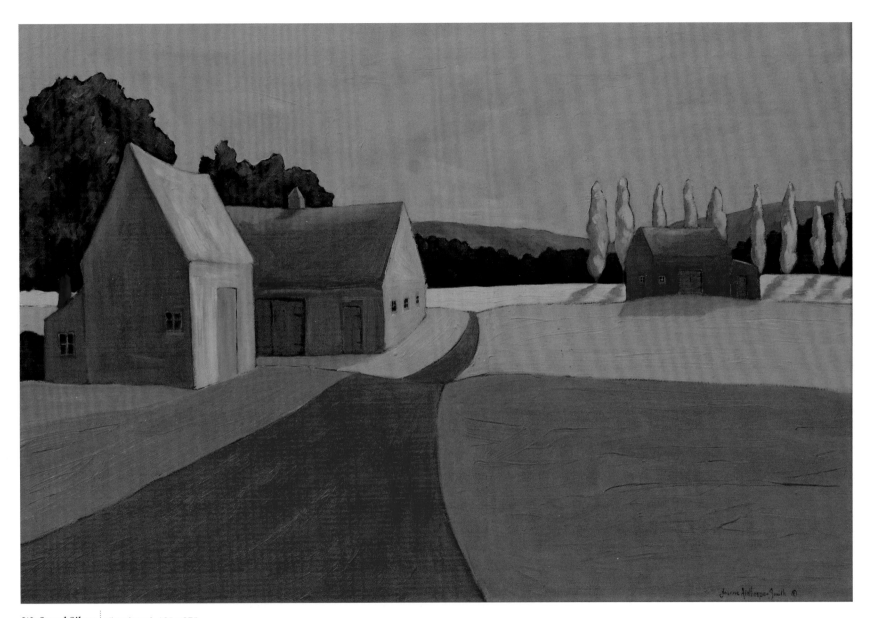

We Stand Silent | oil on board–18" x 27"

Louise Baker

Louise Baker was born in the west, raised in Ontario, and now lives and thrives in the east, where she earned a degree in design from the Nova Scotia College of Art and Design. Since her retirement as an art director in 2001, she has made painting a priority. Baker has been part of many juried group exhibitions, and her paintings are held in private collections throughout North America. She has taught workshops and accepts private commissions. Her work can be seen at the Art Sales and Rental Gallery in Halifax.

I AM GRATEFUL TO HAVE THE DESIRE TO MAKE ART. Primarily I want to enjoy the process—exploring my environment in every season, the enhanced observation, and engaging with fellow artists and art lovers. Having spent my career as an art director/designer, I am always interested in achieving a balance of all design principles in my paintings. My interests and inspirations are many, but the theme that runs through all my work is design and colour. I strive to make sensitive but dynamic impressionistic paintings with expressive brushwork. I enjoy looking for the rhythms, capturing the moods, catching and holding the light, and "revelling in the colours." I search out situations that inspire me to paint, whether outdoors en plein air or with a still subject in my studio. For me painting is totally engrossing and stimulating. I hope the viewer catches a glimpse of my passion for this thing called "making art."

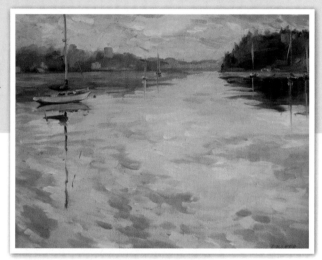

Dusk on St. Margaret's Bay
oil on canvas
11" x 14"

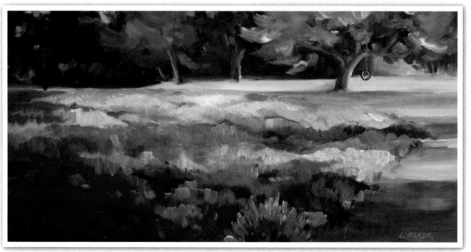

Lavender Fields of Chester oil on canvas–12" x 24"

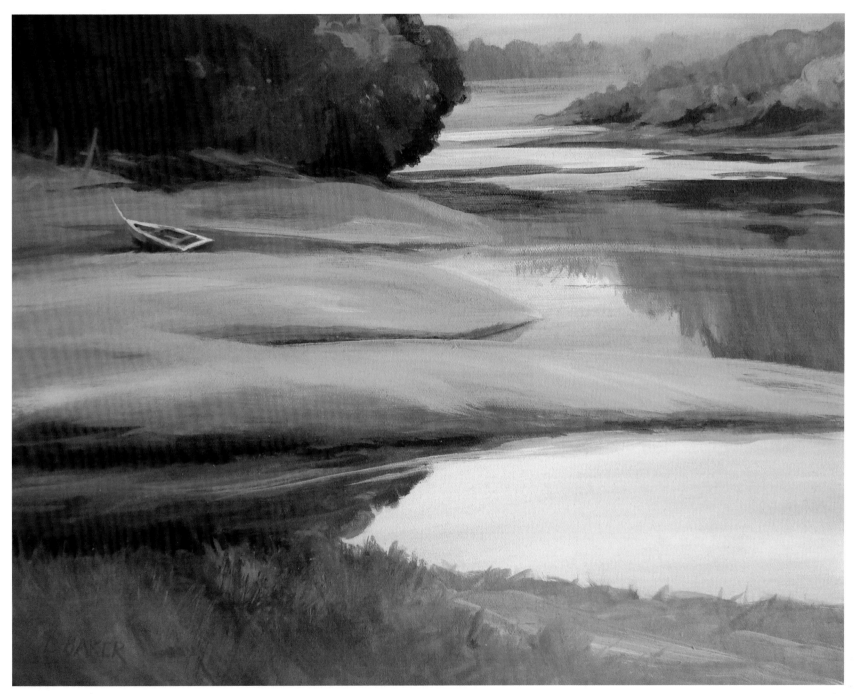

Bear River Inlet | acrylic on canvas–12" x 14"

Alan Bateman

Alan Bateman is forging a reputation as one of Canada's finest realists. He comes from a rich artistic legacy, where painting was a natural pastime. He has inherited the artistic gifts of both his father, internationally known artist Robert Bateman, and his mother, Suzanne Lewis, a superb watercolourist. Alan Bateman was born in Nigeria in 1965, grew up in Burlington, Ontario, and moved to Dartmouth, Nova Scotia, at the age of thirteen. He studied at NSCAD in the late 1980s, and now lives in a two-hundred-year-old farmhouse near Canning, Nova Scotia, with his wife, artist Holly Carr, and their two children.

To paint, I have to live in a place for some time, so I can absorb my surroundings—I'm not comfortable driving around the countryside looking for subjects. Nor am I sure how the evolution works—it just happens while I'm doing things in my day-to-day life. Something worth painting will suddenly become apparent to me—shadows of elm trees against the house, light on a wall, the colours on a hardwood floor. Time and place are as important to me as the central object. Fortunately, for my sanity, and unfortunately, for my prolificacy, this process takes some time. If I spent all day at the easel, there would be no influx of experiences. And if I didn't paint I wouldn't have the intimate parts of my life revealed to me.

Red Evening
oil on canvas
48" x 36"

Boxing Day | acrylic on board–20" x 48"

Young Willows acrylic on board–24″ x 36″

Using oil and acrylic, Heather Beaton has painted the Nova Scotia landscape for over thirty years. After completing her bachelor's degree in philosophy at the University of Saskatchewan in 1976, she moved to Halifax and began her artistic career. Following study with *plein air* painter Arthur Lloy, she spent eight years painting entirely on location. The themes of light, colour, and direct inspiration from nature remain key in her larger studio paintings.

Beaton has also been active as a teacher. In the early 1980s she taught perspective drawing at NSCAD. Since then she has given numerous painting workshops throughout Nova Scotia, and summer workshops with marine artist Graham Baker and Bear River painter Ray Sanford. Beaton is listed in the Halifax Art Map and is represented by Arts Sales and Rental Gallery, Halifax. Her work can be found in the Nova Scotia Art Bank Collection and the Rossignol Cultural Centre, as well as many private collections.

NOVA SCOTIA'S NATURAL BEAUTY IS INCREDIBLY INSPIRING. Each scene has its own qualities and mood— mountain vistas along the Cabot Trail, white pines with their singular beauty, Annapolis Valley orchards in full blossom, and rocky silhouettes near Peggy's Cove. Working directly from nature allows me to observe rare light effects produced by the ever-changing weather conditions. These fleeting moments are often my best opportunities to capture dramatic contrasts and rich colour harmonies. Nova Scotia's abundance of beauty keeps my painting forever fresh and exciting.

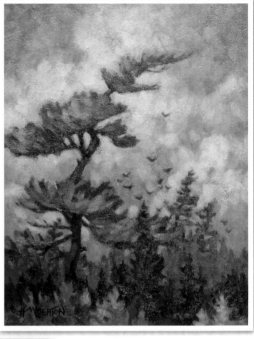

White Pine
oil
14″ x 11″

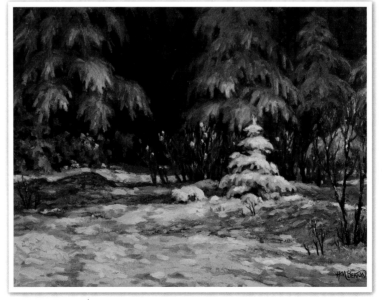

Winter Stillness oil–18″ x 24″

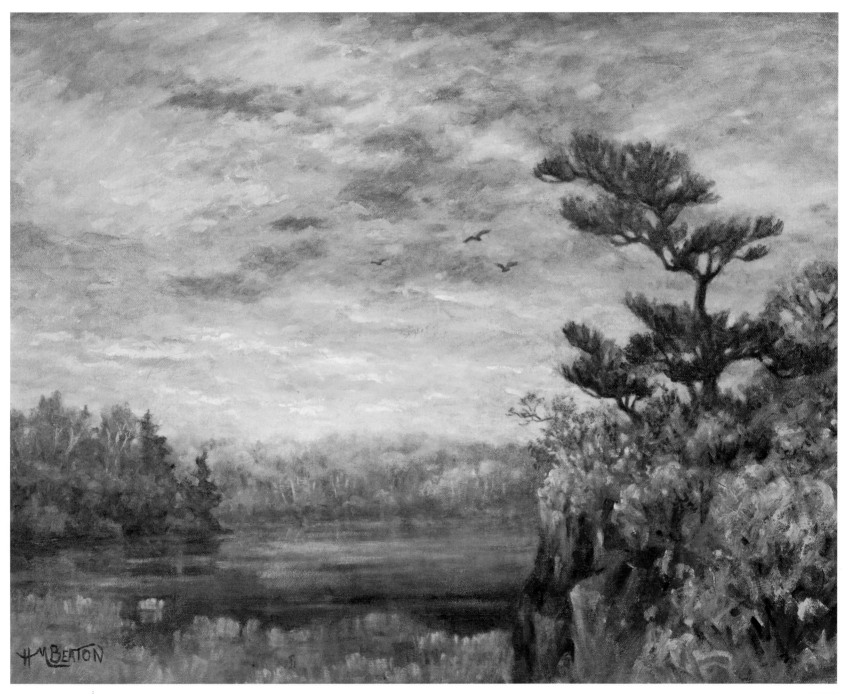

Sunset Rhapsody | oil–18" x 24"

Al Bergin

A mostly self-taught artist, Al Bergin finds inspiration in his everyday rural surroundings. He started his art career in the late 1980s as a high-relief woodcarver. Working in cedar, he produced representations of Canadian wildlife in its natural surroundings. His work was displayed and sold through the prestigious Houston North Gallery located in Lunenburg, Nova Scotia, and on the west coast of Canada. In 1994, Bergin decided to focus only on painting. He painted on hard river stone for several years and completed many commissioned works. Eventually, he decided to paint only on Masonite, and began reproducing his originals in limited edition format. He has received regional, national, and international recognition for his work, including being named a 2009 Ducks Unlimited portfolio artist for his Nova Scotia marinescape painting *Stepping Stones*.

VERY SIMPLY, I TRY TO CELEBRATE, THROUGH MY REALISTIC PAINTINGS, THE EXTRAORDINARY THINGS THAT I HAVE BEEN SO FORTUNATE TO HAVE EXPERIENCED IN MY LIFE. *Every painting has a personal story and my subject matter is varied. I have painted wildlife and people, but my main interest is capturing the uniquely beautiful Nova Scotia land and seascape. As an artist, I feel fortunate to have such a resource that can be so geographically diverse, not only in location, but also in subject matter. I work only in acrylics, using hardboard or stone as my working surface. To me, a painting is finished when I can sit back, stare, and for a second, envision walking into a land or seascape, or reaching out and touching something that, at some time, brought some joy or wonder to my life.*

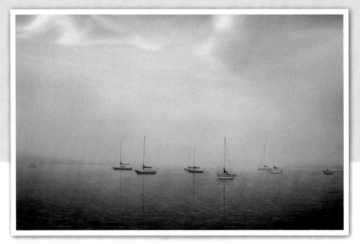

Boats on the Basin
acrylic on Masonite
16.5" x 25.5"

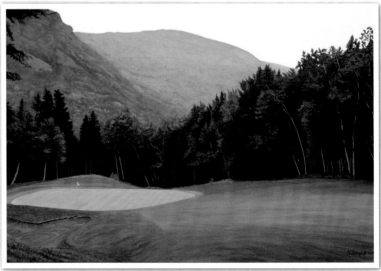

Eyeing on Eagle acrylic on Masonite–19.75" x. 26.75"

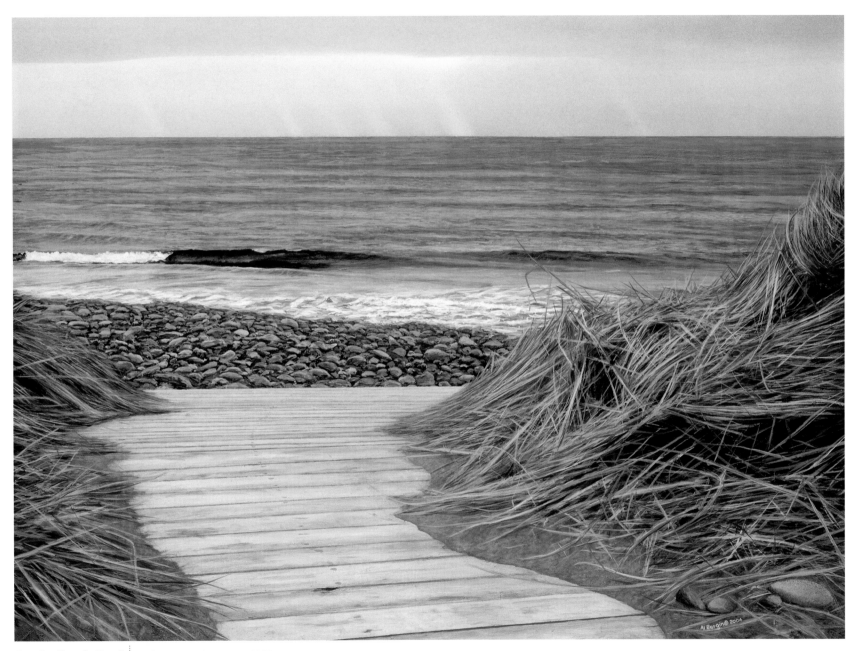

Boardwalk to the Beach | acrylic on Masonite–23.5″ x 31.5″

Kenny Boone was born and raised in Cape Breton and began painting professionally in the early 1990s. As an emerging artist, watercolour was his medium of choice and his surrounding environment influenced his style. Cape Breton Island continues to inspire him to paint land and seascapes, but his creative curiosity has led him in new directions. His portfolio now includes people, abstracts, and another medium—acrylic.

Boone has exhibited his work extensively in private and public galleries in the Maritimes, and his paintings can be found in numerous private collections throughout North America, Australia, and Europe. His work has also been included in the collections of the Art Bank of Nova Scotia, Cape Breton University, Atlantic Lottery Corporation, Stream International, and Dominion Credit Union.

OVER THE YEARS I'VE DISCOVERED THAT ARTISTIC VISION CAN COME FROM ANYWHERE AND AT ANY TIME. If there's anything I've learned, it's to be open to the world around you and concepts for new works will present themselves without effort.

Lunar Light
watercolour on cold
press paper
7.75" x 4.5"

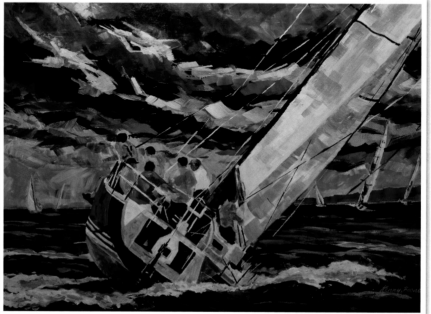

Koobalibre | acrylic on canvas–36" x 48"

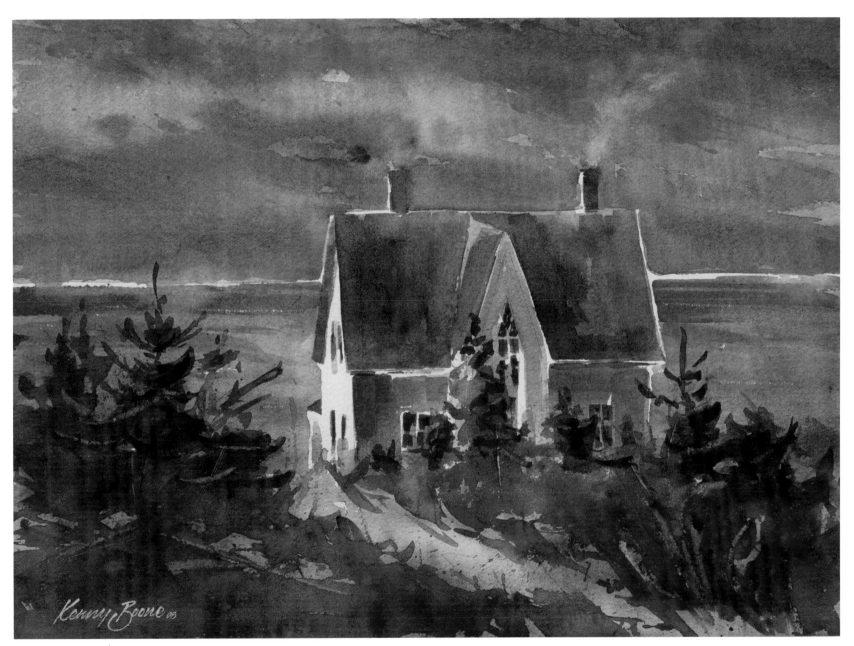

Along the Bras d'Or | watercolour on cold press paper—10" x 14"

Wayne Boucher

Wayne Boucher is the recipient of the 2006 Nova Scotia Portia White Award for excellence, innovation, and expression in the arts. He studied at the Banff Centre, Alberta, and at the Nova Scotia College of Art and Design in Halifax, receiving his bachelor of fine arts degree in 1975. The following year he moved to Graywood, Annapolis County, where he continues his painting practice at his studio in Parker's Cove.

Boucher's solo professional exhibition record spans the past three decades. A major exhibition, Radiance and Counterpoint, curated by Peter Dykhuis, was at the Art Gallery of Nova Scotia in 2006, and at the Western Branch of the AGNS in Yarmouth in 2007.

Boucher has received numerous grants from provincial and federal agencies, including a Canada Council Established Artist Grant in 2001. His other key professional successes include winning the 2004 juried competition to execute the mural entitled *Réveil* for the Interpretation Centre at Grand-Pré National Historic Site. Boucher became a member of the Royal Canadian Academy in 2002.

Since 1975 my painted work has dealt with surface tensions between figuration and abstraction, geometry, and organicism in play with large elemental fields of colour, or black and white. From 1997 to 2000 I utilized a variety of international signalling codes, such as marine signal flags, ground to air signals, and Morse code, in my paintings. These spatial images portended to vast oceanic voyages, and dangerous crossings in opposition with the systemic pattern and codification of the signals. My current painting practice is about the familiar and unfamiliar underworld of watery places and saturated colour space. All I really want people to do is fall in and drown in the work. In the paintings I created between 2002 and 2008, I used colour to create architectural, landscape, and elemental spaces where marks, gestures, and push-pull dynamics inform the theatrics and content of the image.

Spring | oil on canvas–42" x 42"

Mountain and Valley | oil on canvas–30" x 30"

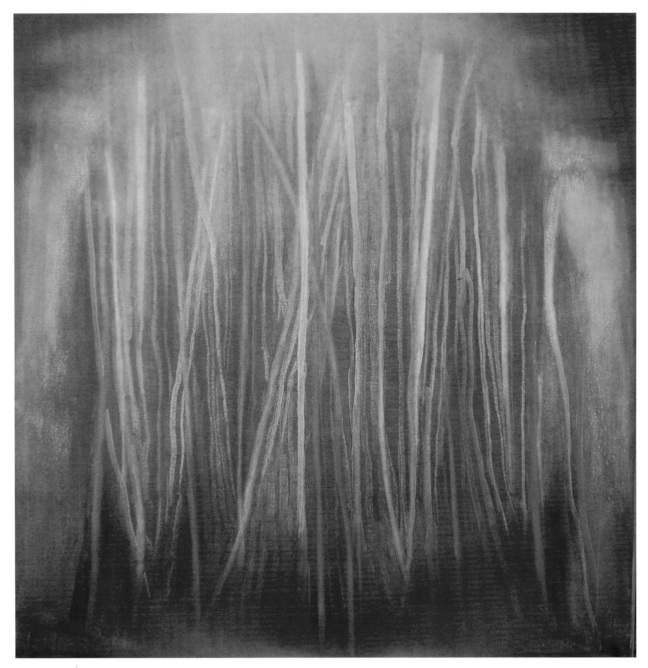

At the Gates | oil on canvas–30" x 30"

Mark Brennan

Born in Swindon, United Kingdom, in 1968, Mark Brennan lives in Whitehill, Pictou County, with his wife and daughter. He trained as a Royal Navy ship-borne photographer in the United Kingdom, covering daily events at sea, including dignitary visits, disasters, sports, and the Cold War. This helped lay some of the technical groundwork for his progression into fine art. Technically, Brennan is self-taught, but he draws frequently on his background as a photographer in his work. He works in all mediums. Painting nature in all its varied forms is his main inspiration. Brennan travels extensively to Canada's many national parks and wilderness areas, where he finds endless visual and spiritual inspiration for his paintings.

My work is derived from the philosophy that to truly represent something in an art form, we must become totally immersed in our subject. I travel extensively into my motif, the Canadian landscape. From this total immersion comes an emotional response, which is expressed through my work. I see the landscape as something pure, containing age-old rhythms and patterns, and with each painting I seek this ebb and flow of nature that holds us all together, forming our connection to all things wild. I want to light up the eyes of Canadians, to awaken them to this wonderful land, to bring the wilderness home.

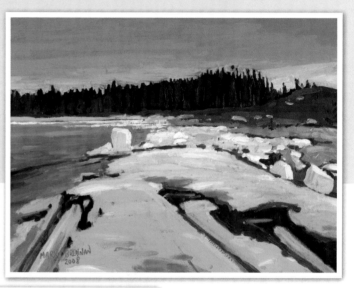

In the Barrens, Canso
coastal barrens
oil
7" x 9"

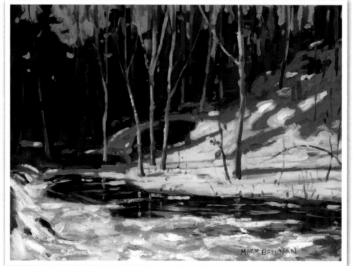

Spring Day, Concord Falls, Middle River oil–6" x 8"

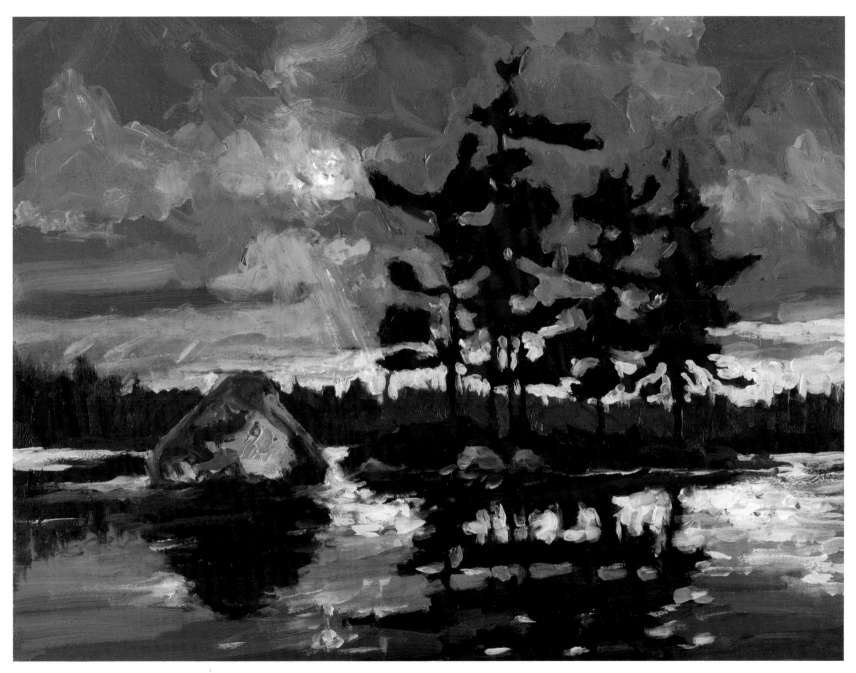

Haystack Rock, Kejimkujik National Park | oil–8″ x 10″

Kathy Brown

A graduate of NSCAD with a Master of Arts in art education, Kathy Brown has been a full-time artist since 1995. She began her career as a book designer with the University of Chicago Press, and later was assistant art director at Ryerson Press in Toronto. In 1974, she began teaching art classes for children at Mount Saint Vincent University, and joined the faculty of education as an art education instructor for two years, before leaving to teach high school art. Brown was coordinator of loans and travelling exhibitions with the Nova Scotia Museum, and coordinator of public programs for the Maritime Museum of the Atlantic. In 2002, Brown was elected a member of the Canadian Society of Painters in Water Colour. Brown's work has been displayed in Nova Scotia at Gallery From the Sea in Halifax, Amicus Gallery in Chester, and Water's Edge Gallery in Baddeck.

WATER IS A BIG PART OF MY LIFE. I have sailed the Atlantic coast for over thirty years, often acting as navigator. Sailors see large skies, narrow bands of land, and colours affected by the watery atmosphere. Sailing and navigating have given me a unique view of landscape, which created a new way of looking at Nova Scotia. Since 1990, as part of this vision, I have often used nautical charts in my compositions. More recently, I have employed painted interpretations of charts, which allows me to vary the size and orientation of the chart for better composition. In some paintings I place the viewer at sea on a passage along the coast, while in others I show activities of sailors. I also paint waves and weather in an intuitive manner. In these paintings I am thinking of shapes, movement, and atmosphere at sea. In all my watercolours I am trying to show more than just what meets the eye as we gaze at the ocean, the boats upon it, and the land beside it.

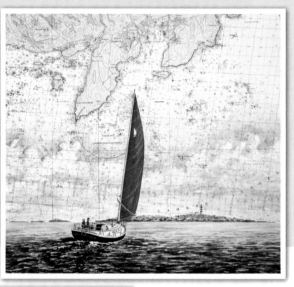

Sambro Light x Two
watercolour and
nautical chart
16" x 16.25"

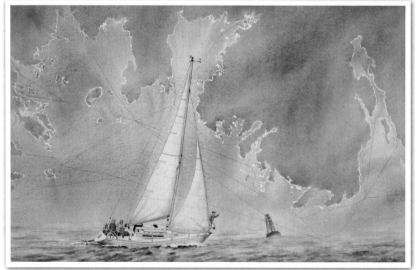

Passing the Buoy watercolour—12.75" x 20.25"

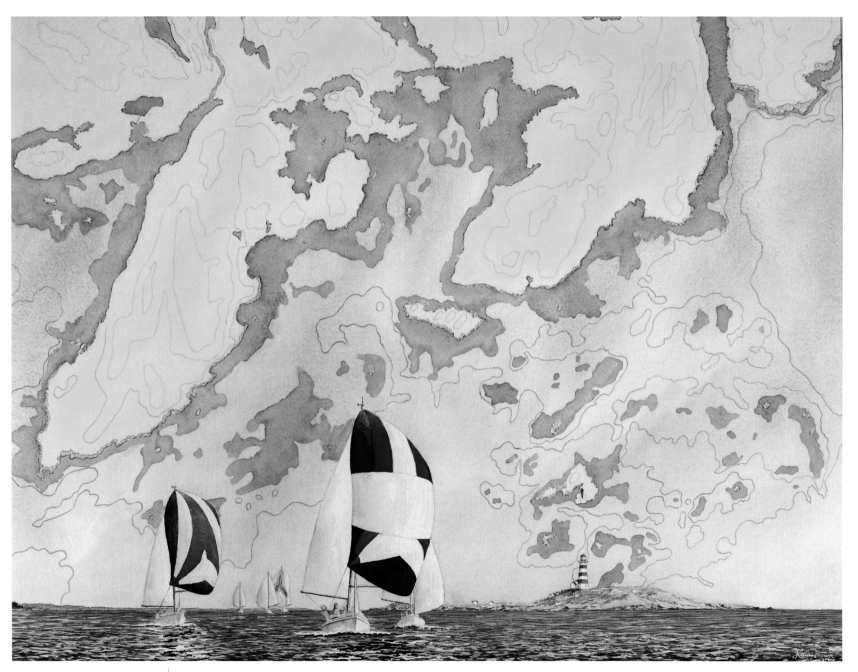

Spinnakers in the Sambro Ledges | watercolour–18.5" x 23.5"

Al Chaddock

Born in Halifax in 1948, Al Chaddock was educated at Dalhousie University and NSCAD. A constant scholar and citizen activist, Chaddock is a pioneer in environmentalism. A singer-songwriter, poet orator, and journalist, he has served on the Nova Scotia Round Table on the Environment and the Economy for five years, representing Canada in the United Nations Conference on Highly Migratory Fish and Straddling Fish Stocks. He was awarded the Order of Halifax in 2000. An accomplished yachtsman, Chaddock's paintings are highly coveted and are found all over the world in hundreds of private, public, and corporate collections, as are his limited edition prints. He has been commissioned by all levels of government and many prominent corporations. A dozen of his works are considered national art treasures of Canada. He currently lives and works in Chester, Nova Scotia.

My work is my statement…and perhaps my life.

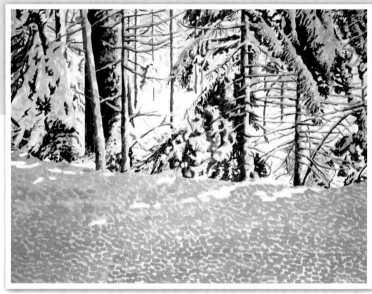

Before Juan, Point Pleasant Park, Halifax, NS
acrylic on canvas
30" x 40"

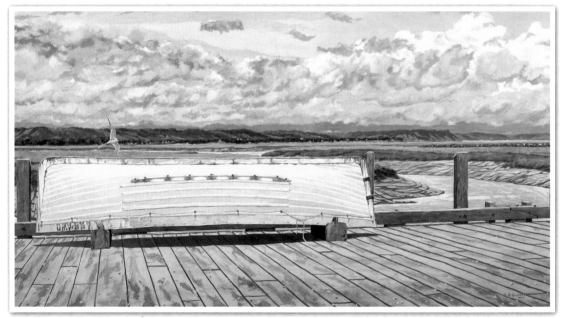

Kipawo's Lifeboat, Wolfville acrylic on canvas–36" x 48"

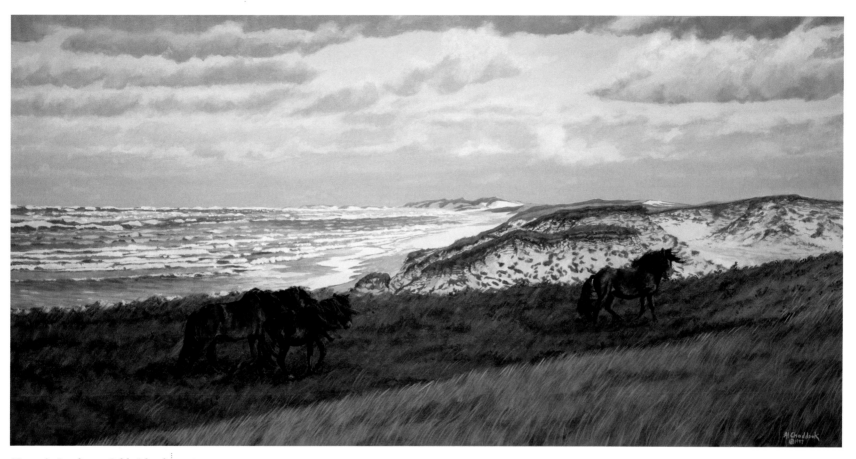

Horses in Landscape, Sable Island | acrylic on canvas–24″ x 48″

Dozay Christmas

Arlene "Dozay" Christmas was born and raised on the banks of the St. John and

Tobique rivers in New Brunswick, the middle child of a large family of nine brothers and sisters. She praises her people's tradition of family togetherness as the inspiration for many of her artistic works. Christmas left the Wolostoq Tobique Reserve when she was eighteen to pursue her education and interest in art. She worked as a trainee with the New Brunswick Museum, under the direction of Robert Percival. She later moved to Nova Scotia and enrolled at NSCAD in Halifax. Her first break as a professional artist occurred in 1982 when she showed an Aboriginal art dealer some of the drawings she had made over the years. Since that time, Christmas has displayed and exhibited her work throughout the Maritimes, Ontario, and the United States. Her work is part of the Aboriginal Collection at the Art Gallery of Nova Scotia. She owns and operates Dozay's Native Art Gallery in Membertou, Nova Scotia.

MY IMAGES ARE INSPIRED BY THE BEAUTIFUL LANDMARKS AND RELATED LEGENDS OF CAPE BRETON ISLAND. We Wabanaki People have a belief that there is a hero here who has always guided us, Glooscap. In many legends, Glooscap used landmarks as a way to guide and teach us. In these landmarks, we see his persona and the lessons he leaves for us are very real, as the landmarks are still here. His teachings will always be here to guide us. Potlotek, one of the landmarks in my images, was made an historical landmark in Chapel Island, Nova Scotia.

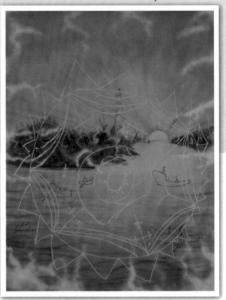

Potlotek, Chapel Island
acrylic on canvas
29″ x 23″

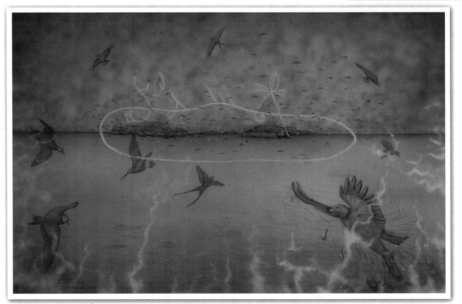

Glooscap's Canoe | acrylic on canvas–27″ x 38″

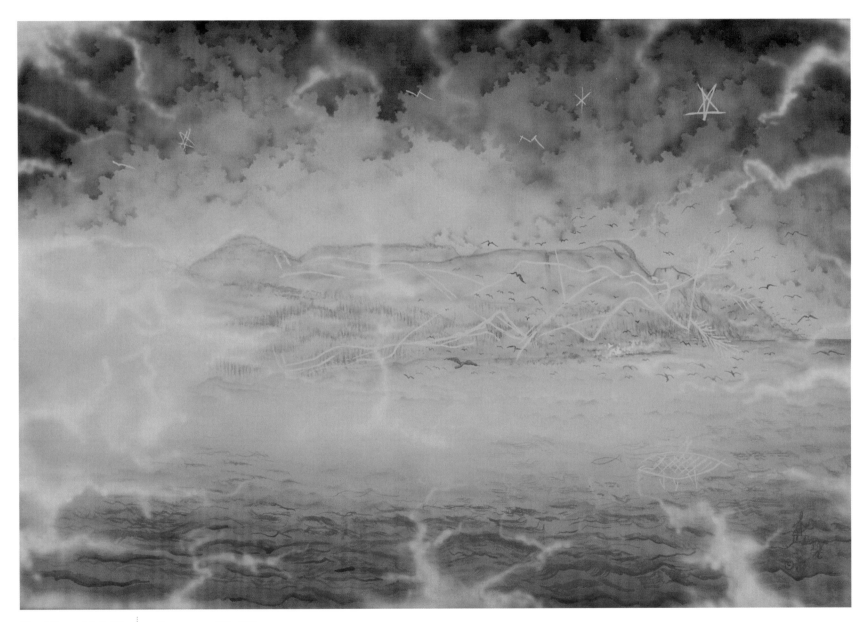

How Niscam Made Him | acrylic on canvas–27″ x 38″

Denise Comeau

Denise Comeau is a well-established Acadian artist. As a lifelong resident of la Baie Sainte-Marie, she has been actively involved in Acadian cultural development in the region. She is also a founding member of La Manivelle fine art print shop.

Denise Comeau habite à la Baie Sainte-Marie et a participé activement au développement culturel de sa communauté acadienne.

Elle est également membre fondatrice de l'atelier d'estampes, La Manivelle.

FOR THE PAST TWENTY-THREE YEARS MY WORK HAS CONSISTED PRIMARILY OF WATERCOLOURS THAT REFLECT THE LANDSCAPE, CUSTOMS, AND FOLKLORE OF ACADIAN LIFE À LA BAIE. *More recently I have begun to explore the expressive qualities of abstract painting. My abstract work offers a more personal expression of Acadian experience and reflects the struggles faced by those fighting to develop and maintain a vibrant Acadian culture in Nova Scotia.*

Au cours des vingt-trois dernières années, j'ai principalement produit des aquarelles illustrant le paysage, les coutumes et le folklore de la vie acadienne à la Baie. Plus récemment, je me suis mise à explorer les possibilités d'expression offertes par la peinture abstraite. Mes œuvres abstraites proposent une vision plus personnelle de la vie en Acadie de la Nouvelle-Écosse et reflètent les difficultés auxquelles font face ceux qui se battent pour instaurer et préserver une culture acadienne vivante en Nouvelle-Écosse.

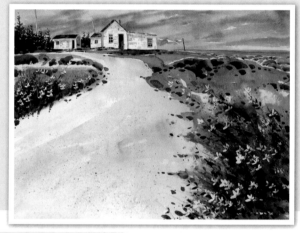

Maison du Cap Sainte-Marie
watercolour/aquarelle
17" x 22.5"

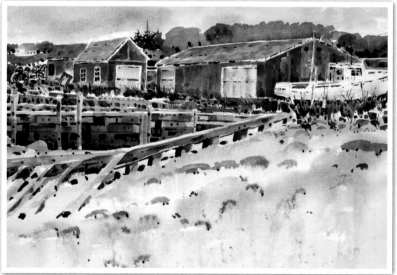

Au Quai de Comeauville watercolour/aquarelle–15" x 22.5"

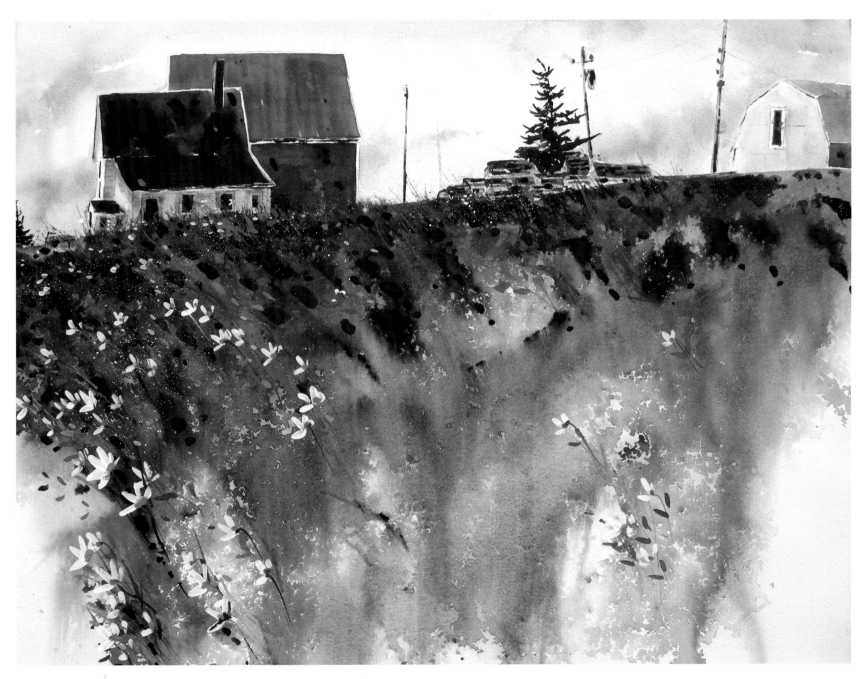

Un Vent du Large | watercolour/aquarelle–22.5" x 29.5"

Sarah Jane Conklin has pursued her artistic interests since 1995. She has been inspired by the scenic communities she has lived in, including Gloucester, Massachusetts; Sackville, New Brunswick; St. John's, Newfoundland, her birthplace; and her current home, Fall River, Nova Scotia. She has successfully exhibited in many galleries in Nova Scotia, including Art Pieces Gallery in Bedford; Red Door Art Gallery in Fall River; and ArtPort Gallery in Halifax. Conklin is currently exhibiting in the Art Sales and Rental Gallery in Halifax, the Cheesecake Gallery in Mahone Bay, and in Fox Harb'r, Wallace. Mostly self-taught, she has taken several art classes through her community and NSCAD. She continues to be inspired by her involvement in local art groups, and her volunteer work at the Art Gallery of Nova Scotia.

NOVA SCOTIA'S ROMANTIC LANDSCAPE AND WILD BEAUTY HAVE INSPIRED ME FOR TWENTY YEARS. Our diverse forests, meandering brooks, waterfalls, and changes of season provide endless inspiration to me. These elements of nature in a kaleidoscopic environment are my primary interest. Motion, mystery, and magic are created through deliberate entanglements of brush strokes and rich colour contrasts. I want viewers to escape, even for a brief moment, into my romantic world.

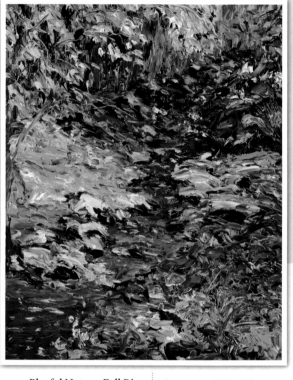

Playful Nature, Fall River — oil on canvas–20" x 16"

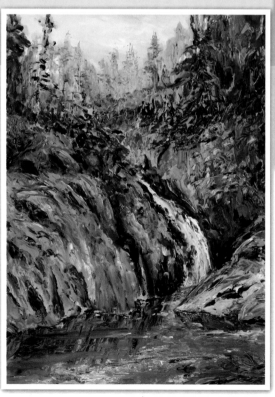

Three Pools, Gaspereau Valley — oil on canvas–24" x 18"

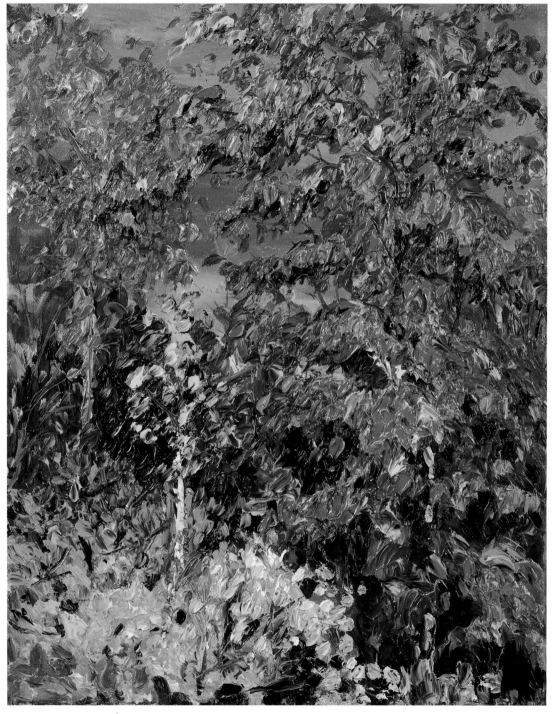

Miss Scarlet, Waverley | oil on canvas–20″ x 16″

Dijon Curley

Dijon Curley has been surrounded by art his entire life. His mother, Rosalie Bishop, and his father, Donald Curley, are both established artists in their own right, and through their encouragement and influence he has acquired his own expressive voice. Executed by a heartfelt response to his environment, Curley's deep appreciation for the landscape, whether it is a field of golden wheat or a pasture of emerald green, is obvious to the viewer. Figuring prominently in his works is the ever-present tree, set against the dramatic, unpredictable sky. Curley's work has been displayed at Amicus Gallery in Chester and Art Sales and Rental Gallery in Halifax.

In every painting I produce there is always an emotional connection, whether a lonely tree in a golden field of wheat, rolling hills next to a red barn, or a rugged coastline; each work coexists with an ever-changing skyline. I strive to capture a moment of tranquility in my work through colour and movement, while balancing between realism and expressionism. My chosen medium is acrylic; its versatility allows me to play with light and shadow. While exaggerating these elements, I continue to focus on producing works that are believable. In today's fast-paced world, with its emphasis on multi-tasking, we tend to be constantly moving. My intention is to give the viewer the opportunity to stop for a moment and recall a memory that is both nostalgic and inspirational, or to take them to a place that allows reflection.

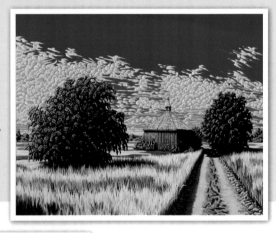

Forgotten Tranquility (2008)
acrylic on canvas
24" x 30"

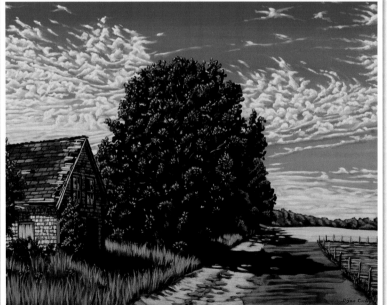

Road to Reflection (2007) acrylic on canvas–22" x 28"

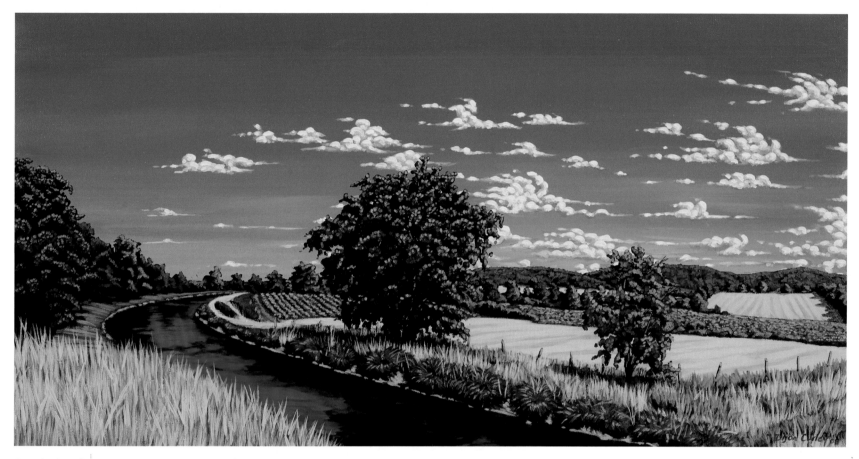

Serenity (2008) acrylic on canvas–12" x 24"

Donald Houston Curley

Donald Curley is a man of many accomplishments. He's been a teacher, lecturer, writer, and world traveller. He is described as an academic artist because of his interest in painting all subjects: landscape, seascape, marine, historical, figurative. His art often tells stories of humankind's relationships with rivers and oceans, forests and mountains. Curley has distinguished himself over the years with numerous donations of his art toward conservation fundraising efforts.

In 1996 Curley was included in "Who's Who in International Art." That same year a stamp featuring Curley's painting *Sunday Morning* was printed in Switzerland as a tribute to him and in honour of this achievement. In 2002 *International Artist* magazine listed him as one of the master painters of the world.

I WOULD LIKE TO BE REMEMBERED AS AN ARTIST WHO PAINTED COMMON THINGS UNCOMMONLY WELL. Artists must demand from themselves a first-hand emotion, not from art, but from life. If I cannot pass effortlessly into the painting and become part of the scene the art will not leave my studio.

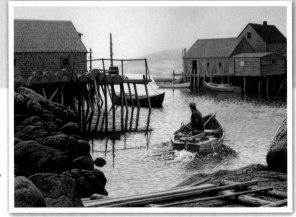

The Lobster Fisherman
oil on canvas, 2008
24" x 32"

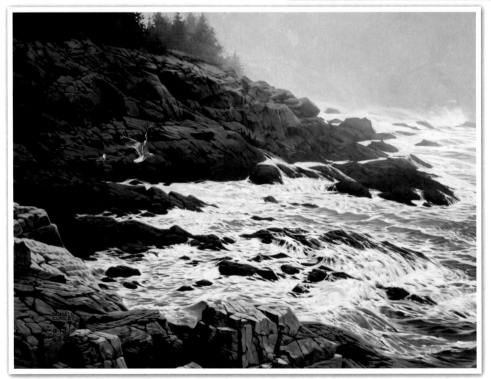

Foggy Coast : oil on canvas–24" x 30"

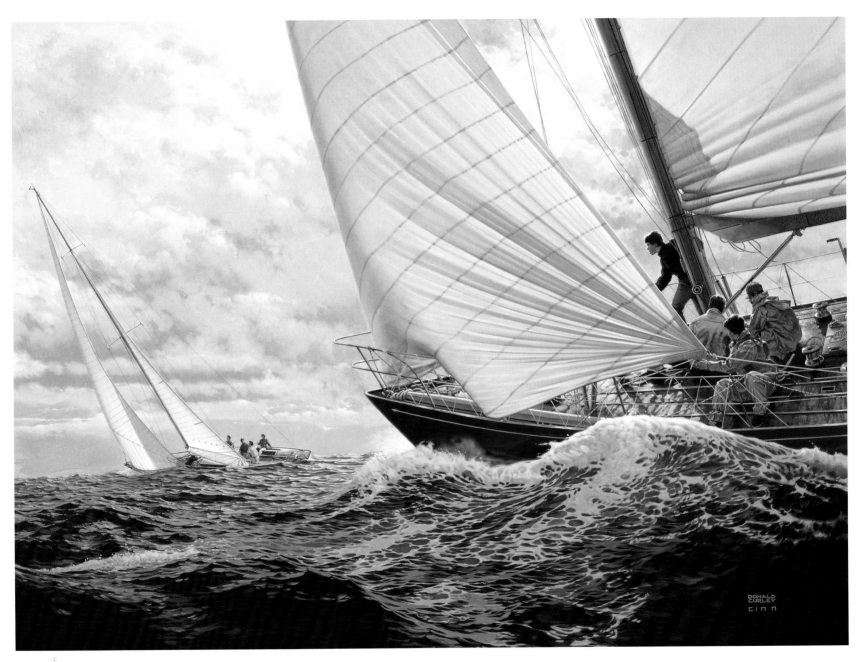

Force 7 oil on canvas–38" x 52"

Cecil Day grew up in Portland, Maine. Her formal education in painting comprised a bachelor of fine arts from Indiana University in 1960 and a master of fine arts from Washington University, 1973. In 1979 she moved to St. John's, Newfoundland, and began printmaking at St. Michael's Printshop. Eventually she taught there and at The Yarmouth Arts Regional Centre (Th'YARC) in Yarmouth, Nova Scotia. Day now works primarily in etching, occasionally in linocut and artist's books. Since moving to Nova Scotia in 1993 she has returned to Newfoundland for residencies at St. Michael's Printshop, Gros Morne National Park, and the Landfall Trust cottage in Brigus. Her work is in the collections of the Canada Council Art Bank, the Nova Scotia Art Bank, and the Newfoundland and Labrador Art Bank, and has been displayed at Harvest Gallery in Wolfville, At the Sign of the Whale Gallery in Yarmouth, and Lyghtesome Gallery in Antigonish.

I LIVE BY THE SEASHORE IN PORT MAITLAND, NOVA SCOTIA; SINCE 1979 I'VE WORKED FROM THIS LAND AND ITS SURROUNDINGS. Sometimes I've made uncomplicated landscapes, responses to what is there, but the human interaction with the natural world interests me more. The Tideline series shows beaches near my house with their particular detritus—some natural, some man-made, sometimes toxic, often quite beautiful.

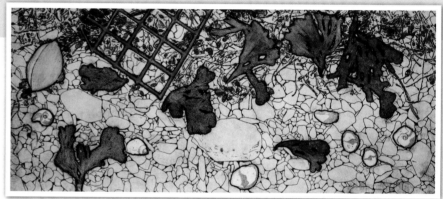

Dargie Cove
etching
9.75" x 23.5"

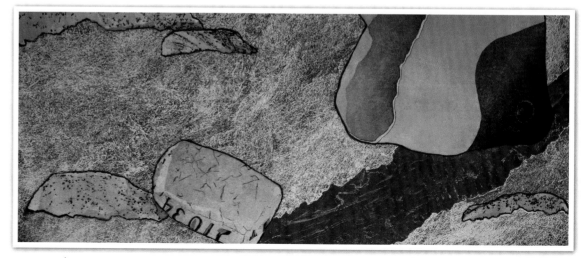

Bear Cove | etching–9.75" x 23.5"

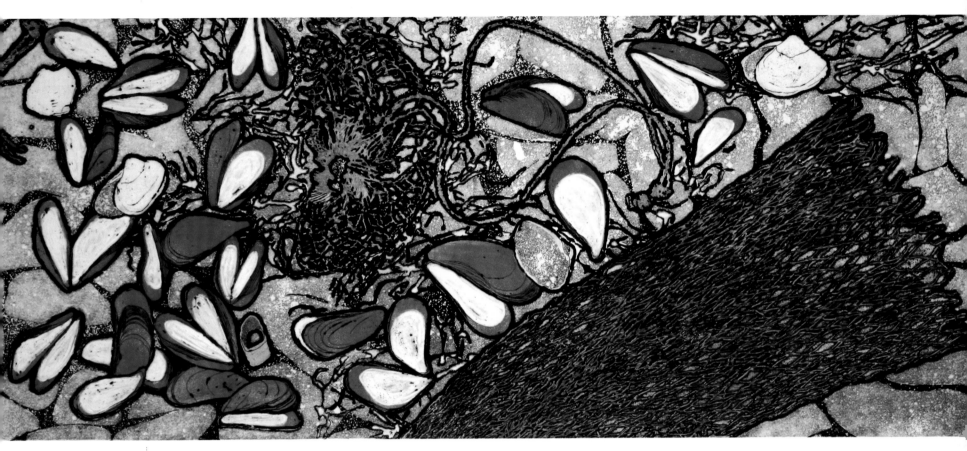

Pointe à Major | etching–9.75″ x 23.5″

June Deveau

The inspiration that guides June Deveau through her work is gathered from the rich cultural background that is rooted in the Acadian villages along la Baie Sainte-Marie, where she resides and works. She endeavours to express the beauty of this area and to honour the traditional crafts, values, and skills of the past. Many of the titles for her paintings are written in Acadian French. In 2008 she received the Prix Grand-Pré, an award presented annually to an Acadian Nova Scotian artist. In the same year Deveau received an award in the micro-enterprise category from *Le Conseil de développement économique de la Nouvelle-Écosse.*

June Deveau peint son entourage, ses souvenirs d'enfance, ses émotions et sa culture acadienne avec une fierté et un attachement dévoué. Deveau a cherché dans son imagination et dans la mémoire collective acadienne, les histoires et les activités quotidiennes de ces ancêtres. Sa carrière d'artiste est définie par plusieurs expositions en groupe et solo en Nouvelle-Écosse, Nouveau-Brunswick, et en Louisiane. En 2008 elle a été récipiendaire du Prix Grand-Pré, présenté chaque année à un artiste acadien de la Nouvelle-Écosse. Elle s'est mérité aussi en 2008 le prix de micro-enterprise du Conseil de développement économique de la Nouvelle-Écosse.

THROUGH MY WORK, I EXPRESS MY ATTACHMENT TO TRADITIONAL VALUES THAT HAVE BEEN PASSED ON THROUGH GENERATIONS. *Exploration of colour, form, texture, composition, and diverse media permits me to share with the viewer my personal impressions. I accept the fact that my style of painting does not describe every detail, but attempts to evoke emotions by using light, form, colour, and movement.*

J'explore les couleurs, les formes, les textures, la composition et des médiums variés pour partager avec ceux qui regardent mon travail mes impressions personnelles. J'ai finalement réalisé que ces coups de pinceau n'allaient pas disparaître. J'ai donc embrassé mon style de peinture en sachant que l'œuvre évoquerait une gamme d'émotions plus que les détails par la lumière, la forme, la couleur et le mouvement. Ainsi celui ou celle qui regarde une de mes toiles peut s'approprier l'image, la scène et l'émotion.

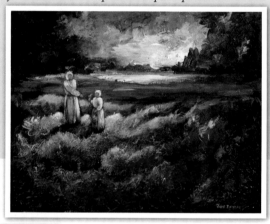

Tranquilité
acrylic
14" x 18"

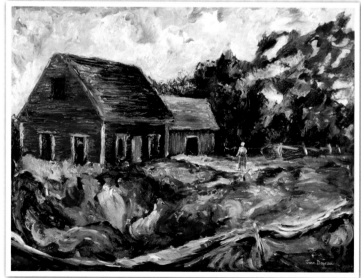

Journée d'Automne ⋮ acrylic–18" x 24"

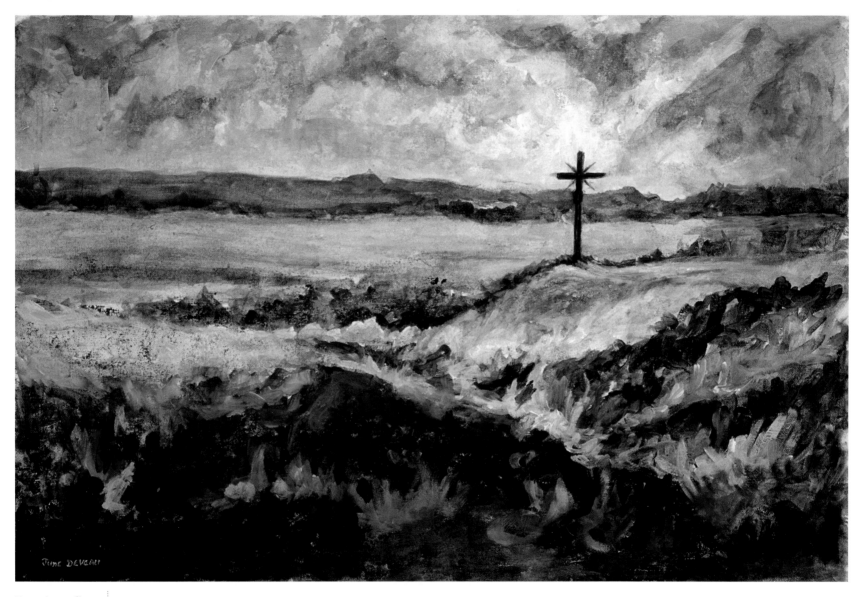

La croix acadienne acrylic on Masonite–16″ x 24″

A resident of Halifax since 1991, Peter Dykhuis has exhibited in public galleries and artist-run centres across the world. He was born in London, Ontario, and after graduating from Calvin College in Michigan in 1978

with a bachelor of fine arts, he lived in Toronto, where he practised as an artist, exhibition designer, and gallery technician. In 1992 Dykhuis moved to Halifax and began working at the Anna Leonowens Gallery, becoming its administrative director in 1996. He has also curated six exhibitions for the Art Gallery of Nova Scotia and has written reviews for several visual arts publications. Dykhuis became director/curator of the Dalhousie Art Gallery in August 2007.

My works entitled Radar Paintings were developed from images of hourly precipitation patterns recorded by radar at the weather station located at the Halifax Airport that were downloaded through the Internet. These radar images were interpreted and transposed into encaustic paint; later works also synthesized hints of corporate logos into the visual mix.

Using the computer monitor as a window onto the landscape of digital culture, Datapaintings manipulate and represent satellite imagery, telemetry and marginal scaling information, microscopic data flows, stock graphs, and corporate logos. Conscious of encaustic paint's 2,500-year history, these multi-panelled works fuse historical content with contemporary issues while skating the line between representation and abstraction.

datapainting.4 (Before Juan, After Nortel) encaustic on twelve panels 48" x 60"

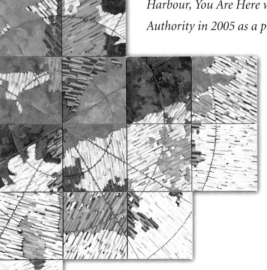

Incorporating envelopes as the foundational layer of a map of Halifax Harbour, You Are Here was installed in Shed 22 of the Halifax Port Authority in 2005 as a play on way-finding maps for cruise-ship visitors.

Since all envelopes were addressed to the artist at either home or work, a complex network of relationships is revealed that fuses personal, professional, economic, and social layers of interaction. The graphic format, however, questions how knowledge, information, and lived experience can be conflated into a "simple" map format, a graphic device that supposedly reflects the landscape of lived and geo-spatial reality.

Apr 28 14:55Z (YHZ Series #1) encaustic, enamel on fifteen panels –60" x 48" installed

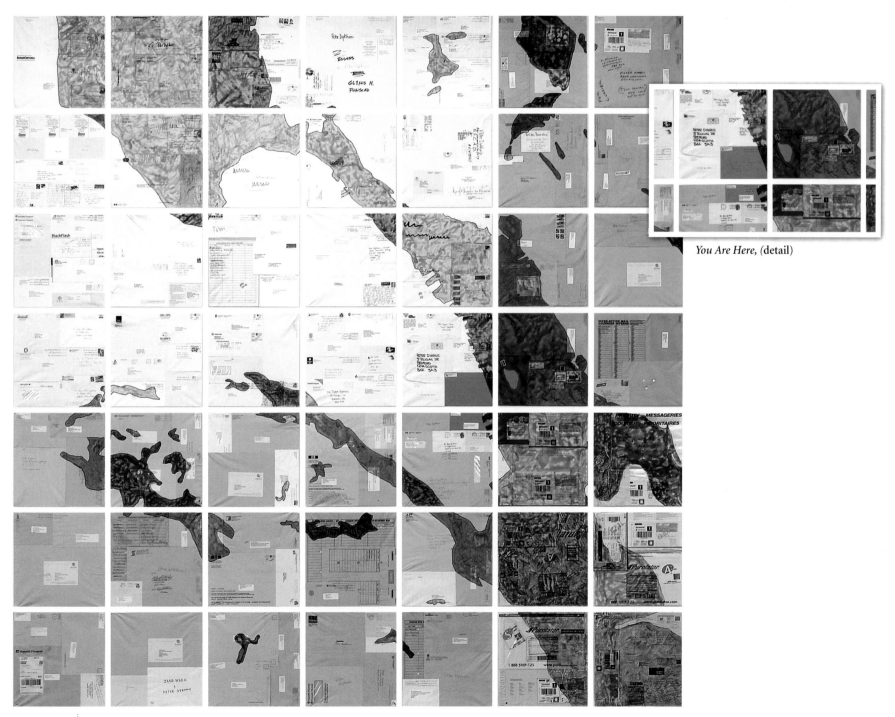

You Are Here, (detail)

You Are Here | encaustic on collaged used envelopes–116" x 116" installed

Susan Feindel

Susan Feindel has been influenced by fishermen, ecologists, and scientists working on the continental shelves of Canada, and more recently, Norway. She has been a guest artist aboard oceanography vessels, including the CCGS *Hudson*, CCGS *John P. Tully*, and GO *Sars*. In 2007, she completed an art residency at the USF Verftet (United Sardine Factory Artist Center) in Bergen.

Susan is a Nova Scotia-born artist whose career spans forty years. She graduated from Mount Allison University in 1966 with a bachelor of fine arts and related music studies. She received an art and science fellowship from the National Gallery of Canada in 1999. Her work is represented by Studio 21 in Halifax and Galerie St-Laurent+Hill in Ottawa.

THOSE FAMILIAR WITH MY WORK KNOW OF MY FOCUS ON THE ECOLOGY OF NATURAL LANDSCAPES ABOVE AND BENEATH THE SEA. *My videos, paintings, and book works on this subject have been seen in five Canadian provinces and were presented in* SCAN *at the Dalhousie Art Gallery in 2005 and* SEE BELOW *at the Mount Saint Vincent University Art Gallery in 2008.*

My sub-seascapes speak of vast landscapes the eye cannot see; of salt water phenomena and sea creatures; of cold water corals and geology. Above sea level, I'm interested in the fluid interface between atmosphere and earth. Humans in this habitat survive beneath the weight of earth's atmosphere much as deep-sea jellyfish thrive under tons of water.

Port Medway, 2006
oil on canvas
10" x 12"

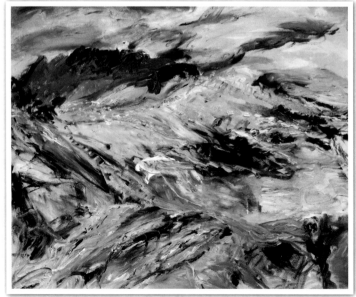

Wreck Cove: Port Medway : oil on canvas–34" x 42"

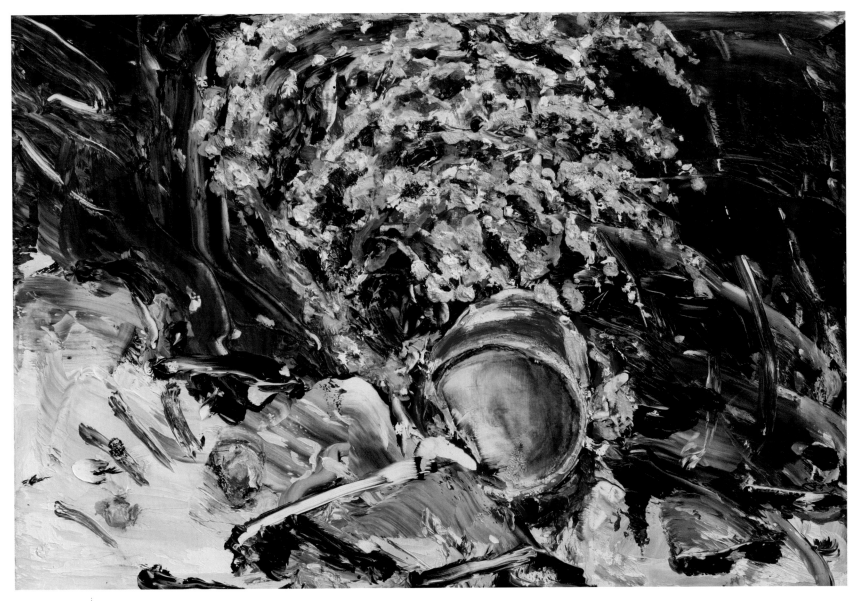

Coral with Cup | oil on canvas–15″ x 24″

Tom Forrestall

Tom Forrestall was born in the Annapolis Valley of Nova Scotia in 1936. He grew up in Middleton and Dartmouth, and began to attend art classes in Halifax at an early age. In 1954 Forrestall was awarded an entrance scholarship to the fine arts faculty at Mount Allison University, from which he graduated in 1958. In the same year he received a Canada Council grant for independent study (one of the first granted), and travelled throughout Europe. In 1959 he became the assistant curator of the Beaverbrook Art Gallery in Fredericton, New Brunswick, and in 1960 received his first major commission—a painting to be presented to Princess Margaret as a wedding gift from the Province of New Brunswick. Shortly thereafter, Forrestall, having supported himself in various related jobs, began to devote himself to full-time painting.

It may seem a bit strange to say, but for me one of the great revelations and joys of painting is the struggle and ultimate failing in each work. Failure is a greater part of art than is ever recognized. It all reassures me that "I've gone a country mile," and battled it all to a standstill. My visions always outpace my doings. The image in the mind's eye, so crystal clear, so complete, too perfect to ever hold in my hand, drives me with a passion to grasp for it. More impulse than logic, my vehicle in battle is egg tempera. It has never let me down and, indeed, in a mysterious way meets me halfway in the struggle—it is a simple and direct medium that I'm very attached to.

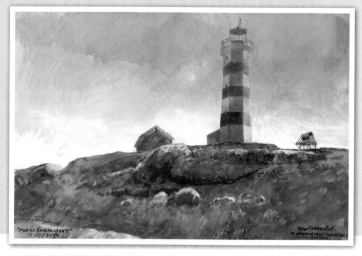

Fog on Sambro Light
watercolour
15" x 22"

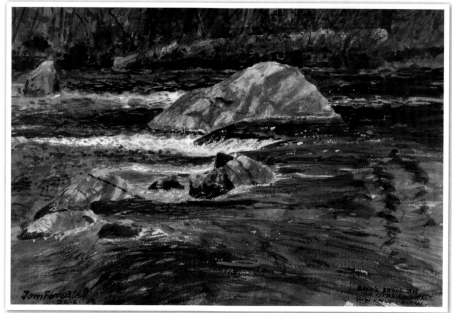

Basil's Brook on the Little Salmon watercolour—15" x 22"

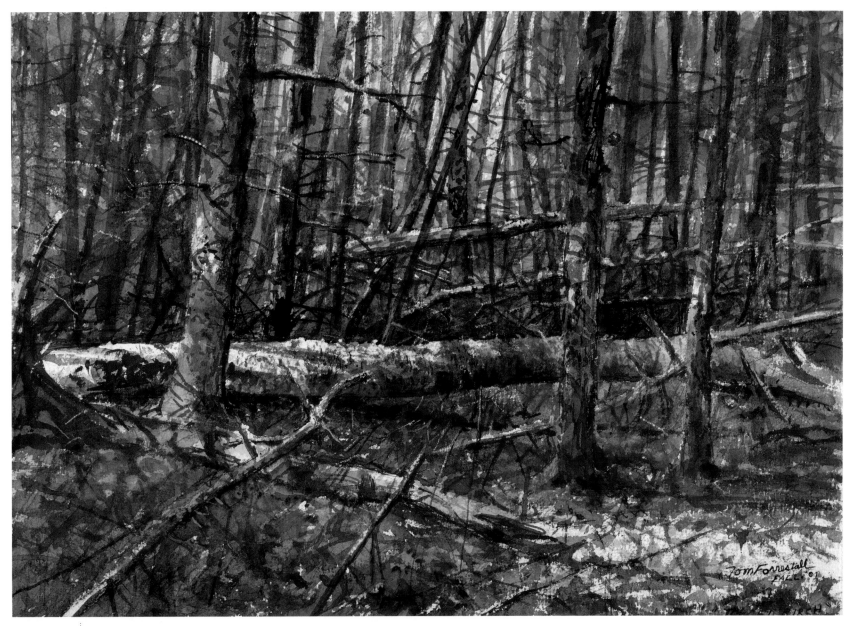

Toppled Birch | watercolour–15" x 22"

Doug Fraser

Living in Cape Breton, Doug Fraser is constantly surrounded by the inspiration of rural life in its simplicity, which is often his subject matter. He enjoys capturing the spirit of life interacting with his surroundings. His use of light, colour, and subject matter creates stories with emotion. As a self-taught artist, Fraser has spent a great deal of the past thirty years reading art literature, visiting museums and galleries, and of course, painting. In the spring of 2007, Fraser opened the Doug Fraser Art Studio and Gallery located on a mountain overlooking the Northumberland Strait in Inverness. He has been working as a professional artist for ten years.

IT IS ESSENTIALLY A PAINTING OF LIGHT. The ideal is to show nature in its strength and its simplicities. To make visible the sublime. By applying thin layers of paint, my goal is to create luminous skies, misty atmospheres, and to create an evocative feeling in each piece. To give us the impression of a particular moment in time, of a particular mood, to make us aware of the awe of this privileged moment.

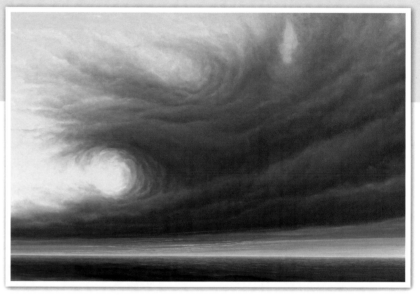

Alluring
oil on canvas
30" x 40"

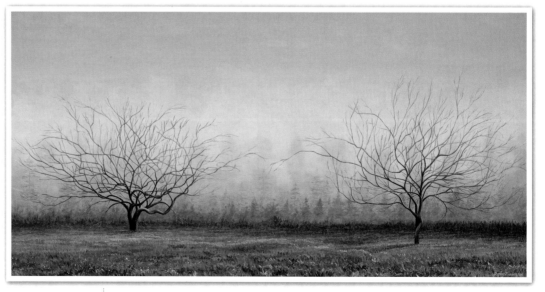

The Wedding Dance | oil on canvas–24" x 36"

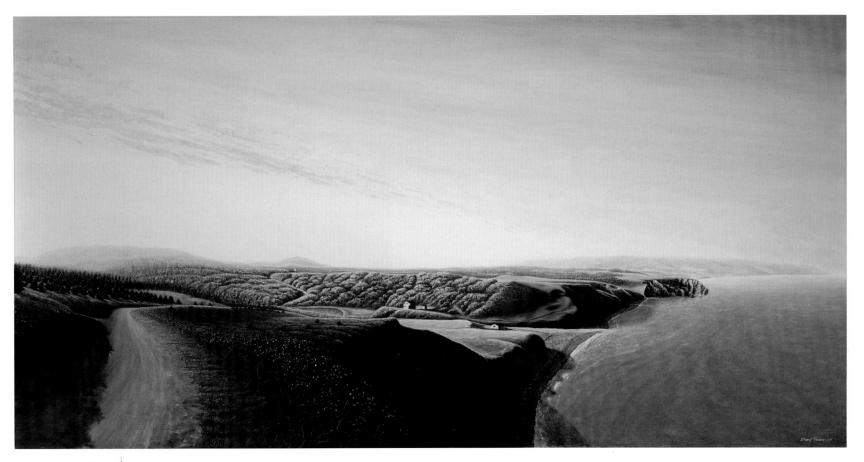

Inverness, Broad Cove | oil on canvas–36″ x 60″

Educated in London, England, at Hornsey College of Art, Valerie Fulford graduated in 1975 with a bachelor of arts (honours) in art and design. She worked for the early part of her career as an illustrator for publishing houses and newspapers.

She also worked as a scientific illustrator for the National Museums of Canada and Agriculture Canada, producing a huge body of work that is now hidden away inside book jackets, waiting to be discovered by enthusiastic botanists and biologists.

After her children were born, Fulford started working exclusively as a fine artist. Since 1992 her paintings have been shown and collected in the United States and Canada; her portraits have been commissioned by corporations, celebrities, and for personal collections.

I LOVE IMAGES. I love colour. I love the journey. Sometimes I wade, other times I fly. The rest of the process I leave to the angels. "Everyone has been made for some particular work, and the desire for that work has been put in every heart." –Rumi

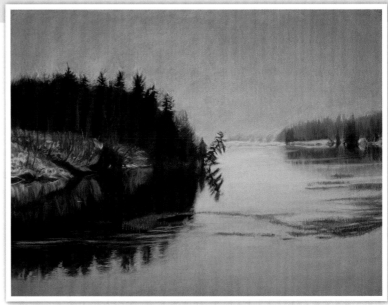

Winter Channel to Point Aconi
pastels on paper
19" x 25"

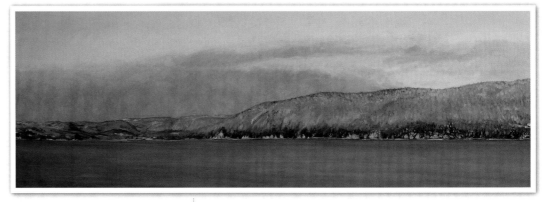

Morning Moon Over St. Ann's Harbour oil on linen–17" x 51"

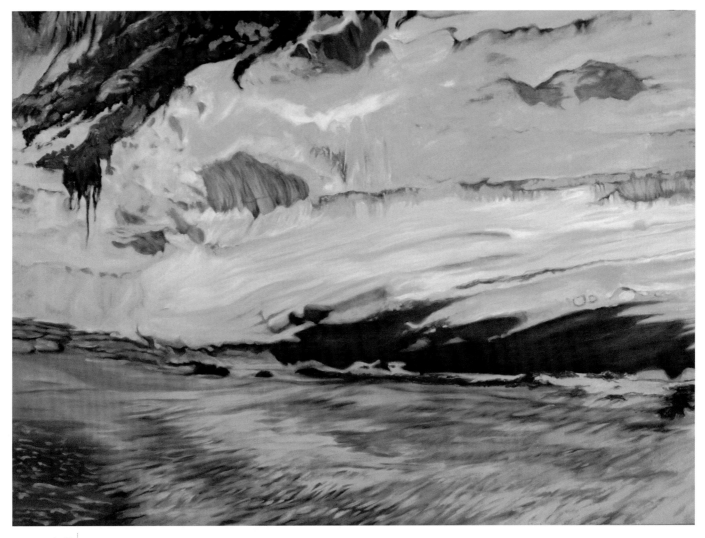

Sunny Bluffs | oil on linen–30" x 42"

Christopher Gorey

Christopher Gorey, CSPWC, was born in Marlboro, Massachusetts, and immigrated to Canada in 1975. He studied at the Massachusetts College of Art in Boston, and has exhibited in galleries across the Maritimes, and in Montreal, Calgary, Toronto, and the U.S. He has won numerous awards, and designed the 1981 and 1987 commemorative silver dollars for the Royal Canadian Mint. His work can be found in various educational institutions, corporate and private collections, and at galleries such as the Art Gallery of Nova Scotia and the Art Sales and Rental Gallery in Halifax. The majority of his work is exhibited at Lynn's Craft Shop and Art Gallery in Ingonish. He has taught drawing and painting at Cape Breton University and through PAINTS (Professional Artists in the Schools). He lives in Ingonish with his wife, Lynn. They have two children.

CAPTURING THE WAY LIGHT ENVELOPS OBJECTS HAS ALWAYS FASCINATED ME. Whether it is the warm light filtering over a landscape in the late afternoon, or the sombre cool light of a rainy day, my subject matter will always be the light. This is not to say that there is no personal attachment to the people and places that I choose to paint. However, I find my first attraction to a particular painting subject usually has to do with what the specific light of the day is doing to that subject. Cape Breton Island offers the inspiration and an abundance of material to pursue this quest.

My influences include the French Impressionists, John Singer Sargent, Andrew Wyeth, and many of the North Shore artists of Massachusetts, where I grew up. My painting has evolved over the years; first working with egg tempera and oil in a high realist style, and gradually moving away from this approach to a more painterly impressionistic application of the watercolour and oil media.

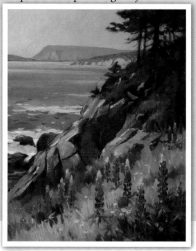

Cabot Trail Lupins
oil on canvas
30" x 24"

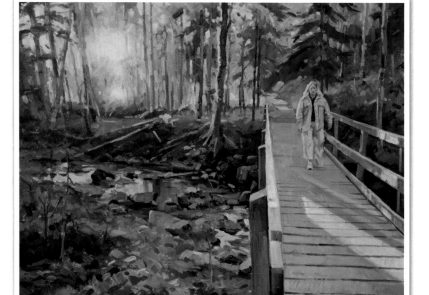

Light Walk | oil on canvas–30" x 40"

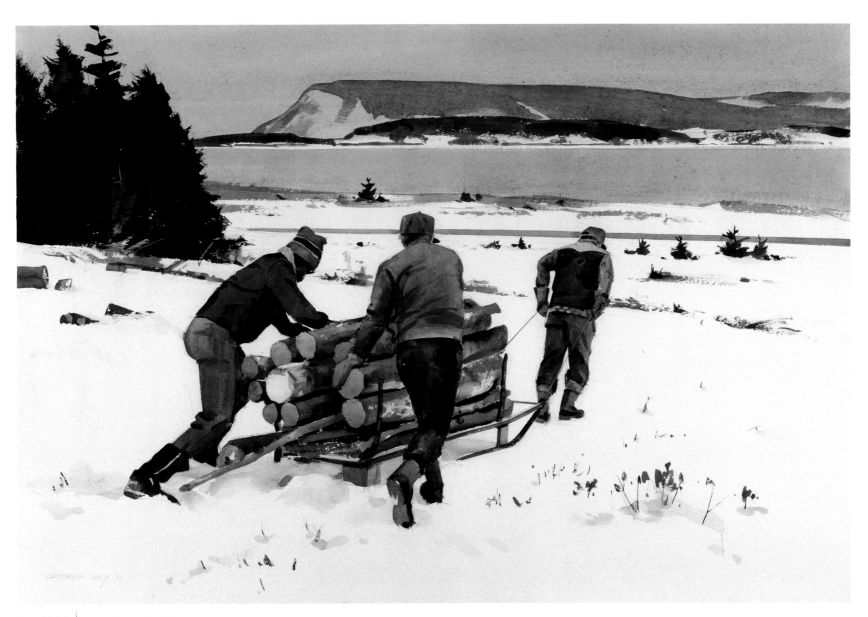

Handsleigh | watercolour–25" x 38"

Peter Gough

Peter Gough was born in Nova Scotia in 1947. He has a home and studio in Glen Haven, Nova Scotia. Gough began his art education at the Nova Scotia College of Art and Design, having received a scholarship in 1969. Three years later, Gough attended Andrews University in Michigan, and continued his fine art education under the influence of sculptor John Collins, who apprenticed with Henry Moore. Gough has exhibited in the United States, Scotland, England, and Canada. He is represented in galleries across Canada and the United Kingdom, and his works are in many private, corporate, and public collections throughout Europe, the United States, and Canada. One of his paintings was presented to His Royal Highness, Prince Philip, Duke of Edinburgh on his royal tour to Canada in 1997.

I BELIEVE THAT EVERY WORK OF ART SHOULD IN SOME WAY BE A REVELATION. It should change us in some degree—both viewer and artist.

Indian Yellow
acrylic on canvas
40" x 27"

(52° 15' 30" N
114° 25' 49"W)

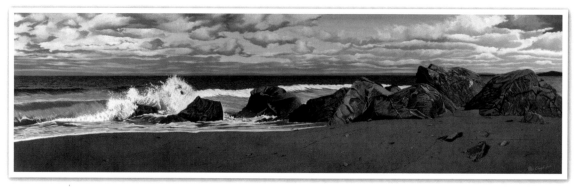

The Parapet acrylic on canvas–24" x 83.5" (45° 42' 00"N 61° 53' 57" W)

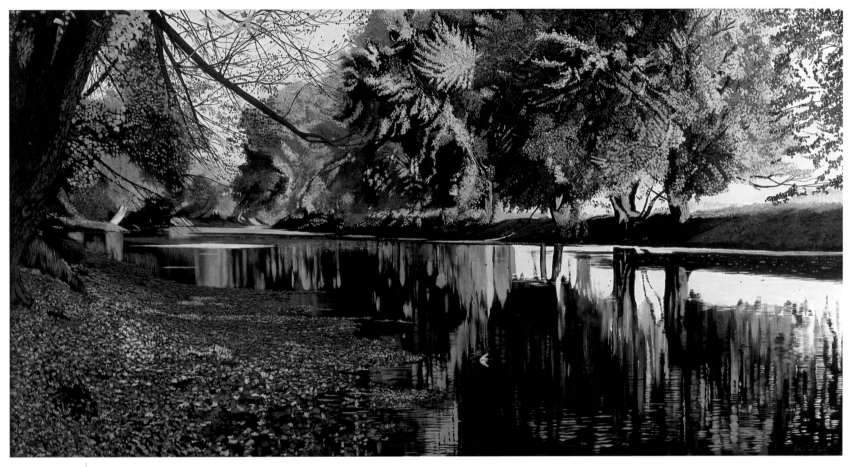

Into the Mirror | acrylic on canvas–36" x 70" (**45° 49' 29" N 66° 07' 15" W**)

Bob Hainstock

Bob Hainstock has worked in Atlantic and western Canada as an artist and journalist for more than three decades. He is a full-time printmaker and painter, a part-time art instructor at Acadia University, and an instructor of several private workshops. His work is primarily concerned with landscape fictions and the potential of texture and colour. He graduated from NSCAD in 1996 and is an award-winning author and illustrator of a best-selling book on rural architectural heritage. His studio techniques include painting and mixed media, collagraphs, woodblock, etchings, monoprints, and experimental processes involving rust/oxidation and handmade paper from Fundy seaweed. He is represented by several galleries in Nova Scotia, including Art Sales Rental and Secord Gallery both in Halifax, and Harvest Gallery in Wolfville.

I'VE BEEN A STORYTELLER AND CLOSE OBSERVER OF THE RURAL PLACE FOR MORE THAN FOUR DECADES—THE FIRST HALF AS A PRINT JOURNALIST IN WESTERN CANADA AND THE SECOND HALF AS A VISUAL ARTIST IN NOVA SCOTIA.
I now live and work in a rural place by choice, locating my home and studio on a high ridge more than six hundred feet above the beautiful Annapolis Valley—an observation post that provides a unique aerial perspective to the changing colours, patterns, and textures of rural landscape and culture. This unusual place of observation is specifically reflected in my artwork of more recent years where different timelines, perspectives, and scales of size are frequently offered within the same picture borders. My work explores the increasing contrasts and frictions between urban and rural cultures, as well as the marks and materials that signify changes in man-made and natural boundaries, or lines of communication and migration.

New Landscapes #320
mixed media on rust
collagraph print
30" x 24"

Time and Place #130 | oil on canvas–39" x 50"

New Landscapes #290 | mixed media on rust collagraph print–22" x 30"

Paul Hannon

Paul Hannon studied at the State University of New York at Oswego, majoring in fine arts. His training focused on drawing, painting, and printmaking with special emphasis on the areas of etching, screen printing, and lithography. Hannon studied at Pratt Graphics in New York City with Anna Wong, and studied studio painting with Elaine DeKooning. In the 1980s, he started a screen-printing and display business in Boulder, Colorado, where he gained experience in the application of screen printing and sign and display manufacture. After moving to Halifax in 1989, Hannon renewed his passion for painting and has become well-known in the Maritimes for his oil paintings, watercolours, and drawings.

THERE ARE TWO MAIN STREAMS RUNNING THROUGHOUT ALL OF MY PAINTING—A NATURALISTIC STREAM AND A SUBJECTIVE STREAM. *My subjective paintings are based more on my imagination and personal vision. My naturalistic paintings look a lot like how things appear. In either style, I look to inhabit all the parts of my painting surfaces with a luminosity arising from light and colour.*

My painting Cloud Shadows *is a subjective landscape; not so literal a depiction, but more an imagined place evolved through process. I sometimes draw parts of landscapes, like fields, roads, hay bales, trees, and clouds. When I have a few parts drawn in a way I like, I begin to reassemble them into a picture, moving their positions and changing their scale on paper, like a director sets prop positions for a film scene. This painting evolved with a certain emphasis, exaggeration, and feeling based on these movable parts coming to rest as the finished piece.*

Road to the Water *and* Fields at Grand Pré *are examples of my naturalistic approach. I experienced these motifs directly. Both of the locations appeared to look like paintings when I first saw them and were compelling images just as they were. They spoke for themselves in their natural appearance, and I listened through developing these paintings.*

Road to the Water
oil on canvas
34" x 40"

Fields at Grand Pré oil on canvas–25" x 40"

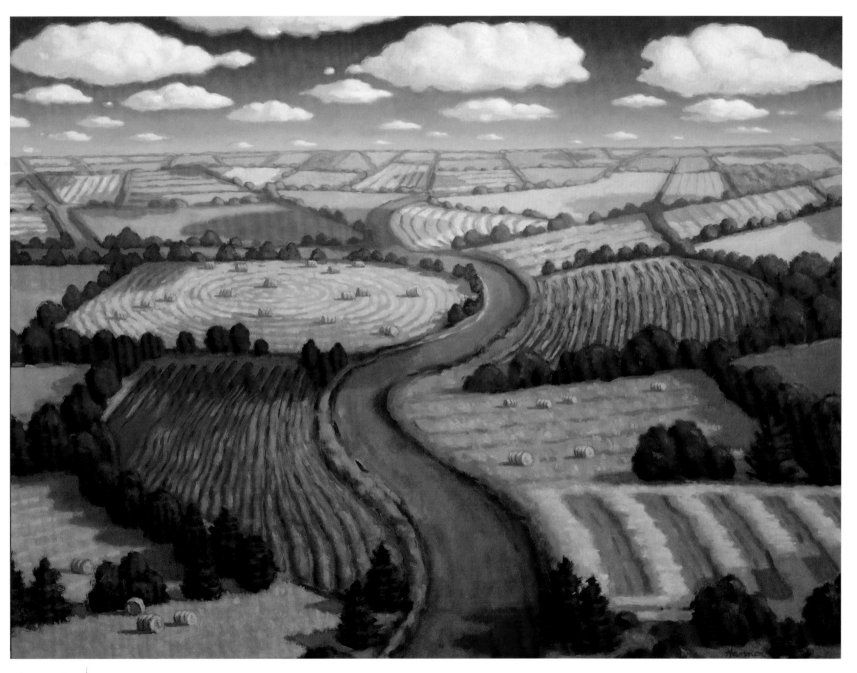

Cloud Shadows | oil on canvas–30" x 40"

Ron Hayes

Landscape painting has been a passion of Ron Hayes for over thirty-five years. Since opening Art Can Gallery in Canning in 2001, he has been actively involved in the support and promotion of the arts in the Annapolis Valley. His latest landscape paintings are large, textured canvases of the Annapolis Valley, where he now lives. In the 1990s Hayes returned to school to study expressive arts. He continues to find a source of inspiration in the Maritime landscape. His work has been displayed at his gallery in Canning, and at Pilar Shephard Gallery in Charlottetown, Prince Edward Island.

I BELIEVE THAT AN OUTSIDER'S PERSPECTIVE HAS ITS ADVANTAGES. *When my surroundings are new my senses become heightened and this feeling of aliveness adds fuel to my creative process. Capturing the power and rhythm of the Annapolis Valley has become my main focus since moving to Nova Scotia from Toronto with my wife and three children in 1996. In creating this series of paintings, materials such as sand, stone, and shells were collected and embedded into the work. I draw on historical examples of the great landscape tradition to inform and direct my own work. By exemplifying these traditions, I create a solid foundation from which the exploration of the contemporary landscape can be made. These three paintings represent this very exploration, reflecting not only the familiar environs in which they were created, but also evoking great artists who shaped the practice of landscape painting.*

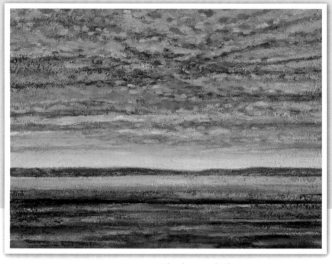

Rhythm and Blues
acrylic on canvas
18.5" x 40"

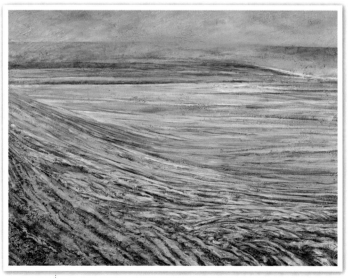

Afterglow acrylic on canvas—11" x 16.5"

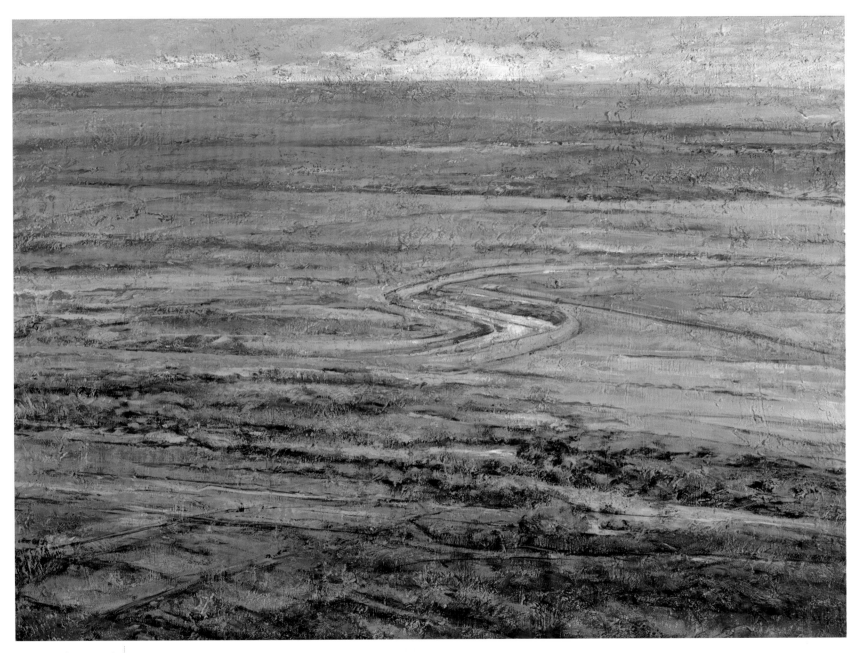

From South Mountain | acrylic on canvas—36" x 48"

Ron Hazell

Ron Hazell was born and raised in Halifax, Nova Scotia. Although he followed a career as a professional engineer, he also pursued a parallel career as a fine artist through self-study. Hazell is an accomplished artist in the mediums of both oil and watercolour. In 1997, he was elected to the prestigious Canadian Society of Painters in Water Colour (CSPWC). Since retiring as an engineer in 1998, he has painted full-time. His subject matter is wide-ranging, but he is best known for his light-filled cityscapes and for his paintings of Nova Scotia's coastal communities, including the people, their boats, and the sea.

His award-winning paintings are held in private collections throughout Canada, the United States, and Europe, including the Royal Collection of Her Majesty the Queen at Windsor Castle. They are also on display in corporate collections across Canada. His work has been published in *American Artist: Watercolor* magazine, as well as by International Artist Publishing.

TWO THINGS HAVE ALWAYS FASCINATED ME—LIGHT, AND ITS INTERACTION WITH WATER. *Morning is my favourite time, particularly when the sun's rays filter through the lifting fog, scattering into countless facets of light, a sparkle of brilliance on the lake where I live, or on the Atlantic Ocean just down the road from my studio. I attempt to quickly record such moments in paint, to capture that light, and share its fleeting beauty with others. Flooding a scene with light makes it sing.*

My favourite medium is watercolour; it is ideal for painting light, as well as painting water. Water is a constant theme in my work. I paint water in just about every form possible, from lakes and rivers, to protected coves and inlets, to the raging open ocean. Even fog, snow, and rain creep into my paintings. Places where people live their lives, work, and play have also been a common theme in my work, so villages, towns, and cityscapes are among my favourite subjects. I like to paint the ordinary moments that we all experience in everyday life. If others can identify with that experience by viewing my work, I have succeeded.

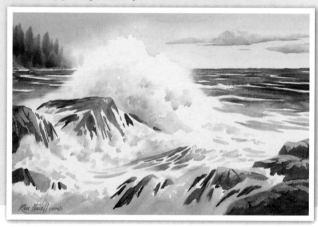

Remnants of Storm Noel
watercolour
15" x 22"

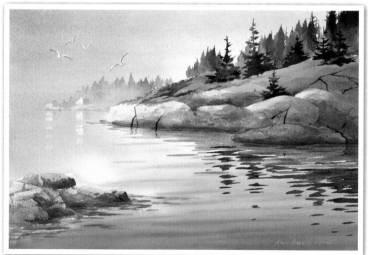

Indian Harbour | watercolour–15" x 22"

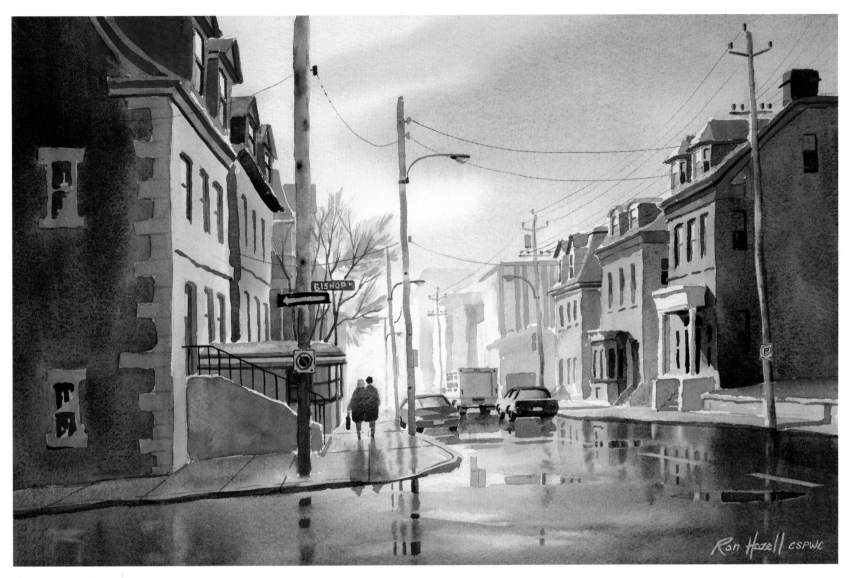

Showers on Barrington | watercolour–15" x 22"

Alice Hoskins

Alice (Brunton) Hoskins was born in Montreal and educated in England. She pursued the study of fine art at L'École des Beaux Arts, Montreal, and the Montreal School of Art and Design under Arthur Lismer, subsequently completing a bachelor of fine arts and master of fine arts in art education at NSCAD. She served as education officer and then education curator at the Art Gallery of Nova Scotia in Halifax for nine years, and went on to complete a graduate program in leisure studies at Dalhousie University. She has travelled extensively, having lectured on aspects of art in both Australia and Japan. She has written two books based on her travels in Japan, which include many ink sketches completed on site. Hoskins has held many important positions as an educator and curator, and received many scholarships and awards. She has belonged to many organizations and art societies, and has exhibited in both solo and group exhibitions. She is represented in both private and public collections. Hoskins brings a bold and refreshing hand to her figure and floral studies, landscapes, and seascapes. She prefers to paint on location, making eloquent use of the spacious and luminous qualities inherent in the watercolour medium. Her work has been displayed at Lyghtesome Gallery in Antigonish.

LANDSCAPE PAINTING FIRST BECAME A PLEASURE FOR ME AS A TEENAGER SPENDING SUMMERS AT OUR SUMMER HOME NEAR GUYSBOROUGH IN NOVA SCOTIA, WHERE I WAS INSPIRED BY THE NATURE THAT SURROUNDED ME. *In 1961, I attended the Montreal Museum of Fine Arts School. After graduating, I took Arthur Lismer's art teacher's course and discovered that I loved teaching. In 1984 I settled in Halifax and began to paint landscapes. At art school we had used oil paint, but I found that oils were not my medium. A need for more brilliant colour made me return to watercolour. After retirement, my move to Antigonish brought me to a beautiful area of the province where the landscape possibilities are infinite. I have a basic need to paint on the spot where the light changes, things move, and nature is alive, ever in flux.*

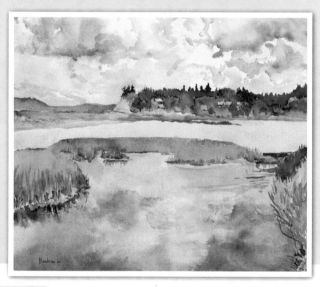

Ogden's Pond watercolour–14" x 17"

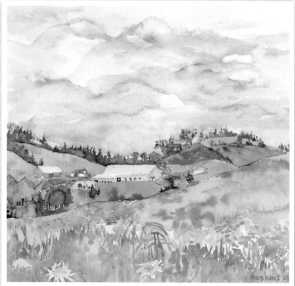

Dandelion Season watercolour–13" x 14"

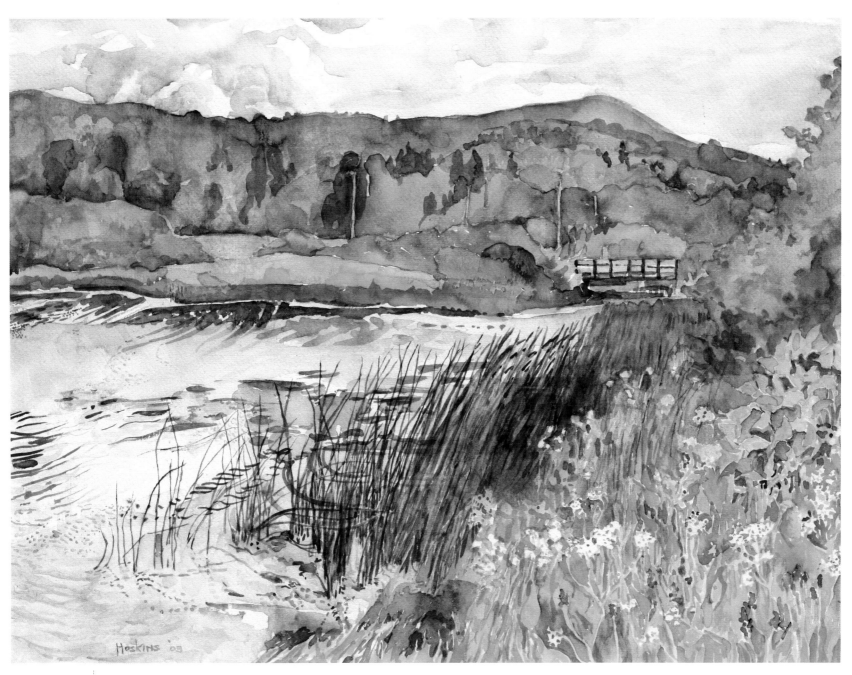

St. Josephs Lake | watercolour–14" x 18"

J. William Johnson

Born in Fredericton, New Brunswick, in 1948, Johnson graduated from the University of New Brunswick with a teaching certificate in art. He attended NSCAD, graduating in 1975. He worked as reporter and illustrator for the *Fredericton Daily Gleaner* and was assistant editor of *Atlantic Advocate* magazine in Fredericton. In Toronto, he worked as a conservation framer and artist, and after moving to Halifax in 1980 he worked as an illustrator and designer, art director, and creative director with various companies. Johnson has been a full-time artist since 1995, maintaining a studio in Dartmouth where he lives with his wife, Dawn Russell, and three children. Johnson has exhibited in group and solo shows in Toronto, Oakville, Fredericton, and Halifax since 1968. He has been represented by galleries in Toronto and Halifax, and his works are owned by collectors across Canada and in the United States. Recently he has focused on mural painting in and around Halifax.

AFTER DECADES OF PAINTING PICTURES I AM LEFT WITH ONE INSISTENT QUESTION: WHY DO I PAINT? I HAVE NO ANSWER TO THIS QUESTION. *I do know that it is not a matter of choice, but a need, like the need to eat for example—but then I know why I eat. Unlike physical hunger, which can be satisfied then forgotten, this creative hunger is never sated. There is not a painting I have done that meets the criteria of "a full meal." And even when I see the incredible talent about me, talent far greater than my own that may cause ripples of odious envy, it humbles me, yet never extinguishes my desire. I have mantras such as, "I paint only for myself," yet I know this to be false for I do exhibit my paintings, or "I want to sell my work," but this too is misleading, for I prefer to circumvent the commerce of art. So why do I paint? It is said that birds do not sing to give answers. Birds sing because they have a song. Perhaps it is simply that. I have an image that I want to paint.*

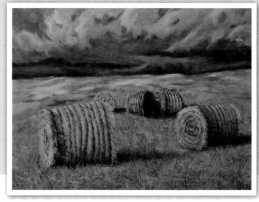

Fields of Gold
oil on canvas
16" x 20"
(courtesy Sir Graham and Lady Ann Day)

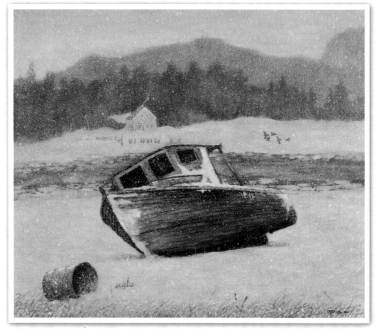

Christmas Day oil on canvas – 30" x 40" (courtesy Purdy and Bea Crawford)

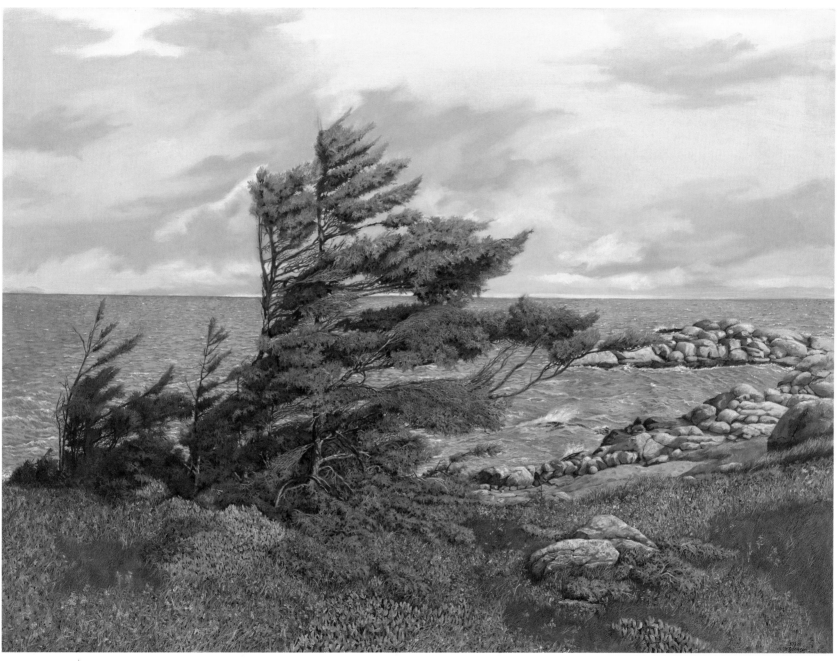

Chebucto Head | oil on canvas–36" x 48"

Marilyn Kellough

Marilyn Kellough is a watercolour artist who "celebrates the beauty that was and that which remains" (S. C. Greek). Her style is best described as "gutsy and invigorating. She gives new life to beacons like a rotting country mailbox or a trinity of dories resting on still water" (E. Barnard). Her works reflect everyday life and the common objects around us. Born in Annapolis Royal, Nova Scotia, she now lives in Port Mouton, Nova Scotia. She is a graduate of NSCAD with a bachelor of fine arts.

Kellough's work has been exhibited from Toronto, Ontario, to Gander, Newfoundland. Her paintings can be found around the world in private and corporate collections, including the Canadian Imperial Bank of Commerce and the London Life collections. Her paintings are in galleries throughout Atlantic Canada, including Art Sales and Rental Gallery in Halifax, Details Past and Present in Charlottetown, Kellough Art Studio in Port Mouton, and the Ewing Gallery in Cornerbrook, NL.

My watercolours are often described as realistic, bold, gutsy, vibrant, and sparkling, but also sombre and calming. Incorporating a variety of watercolour techniques, such as scratching, wet on wet, splatters, salt, and a variety of brush strokes, combined with my palette, enables me to communicate the essence of Nova Scotia's vast variety of landscapes. As a teenager watching Tom Forrestall paint, I was in awe of how he brought life to his landscapes. He basically put a brush in my hand and encouraged me to "just paint." Those words were pretty intimidating, but were also powerful in helping me to develop my own style and sharpening my determination to be an artist. My intent as an artist is to give new life to everyday situations, images of days gone by, overlooked decaying farms and vistas. If one experiences a nostalgic or an emotional response to my paintings, I feel that I have accomplished my intent.

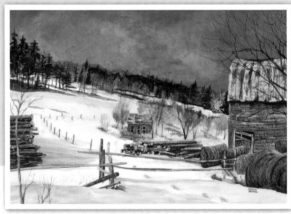

Winter's Lull
watercolour
14.5" x 22"

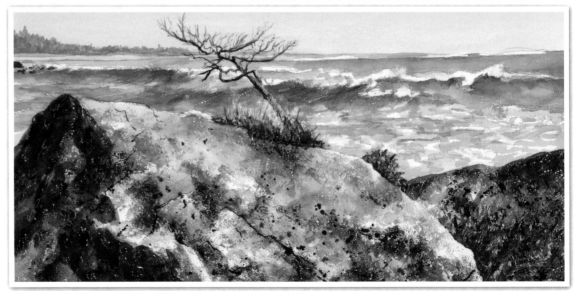

Wind Swept | watercolour–9.5" x 20"

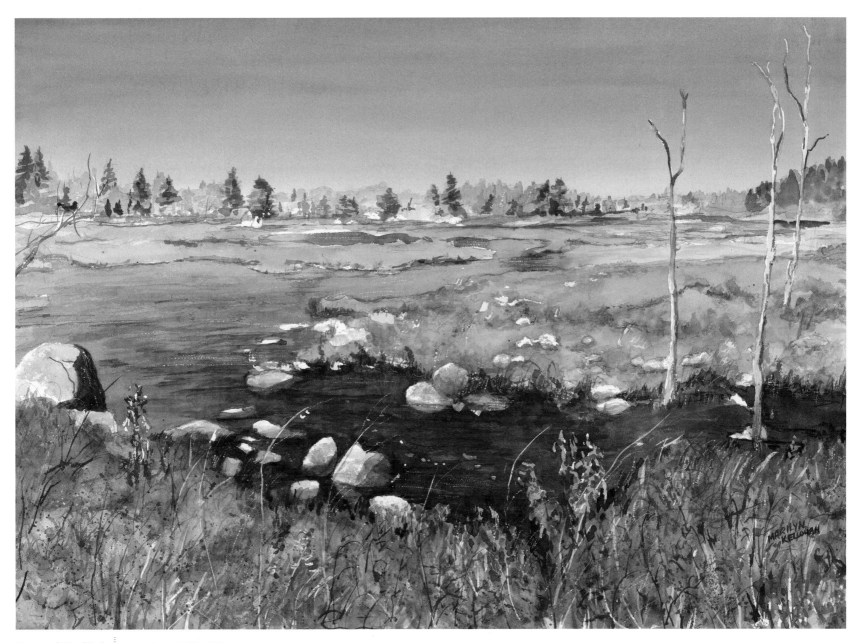

Liverpool Head Lake | watercolour–15.5" x 22"

David Lacey

David Lacey was born in Woodville, in the heart of the Annapolis Valley. After graduating from the local high school, he spent some time at NSCAD. For the next ten years, he dabbled at painting and photography, but was employed in other fields. In the early 1980s a watercolour course at the local university piqued his interest and provided him with some of the basic technical background that he had been lacking. In 1988, at the encouragement of his partner, Heather Stephens, he opened the David Lacey Gallery adjacent to his 1825 Cape Cod–style house. Located on a hill overlooking Hall's Harbour, the gallery has been in seasonal operation ever since.

TO ME, ART IS ABOUT SEEING—NOT JUST NAVIGATING THROUGH THE MAZE OF LIFE, BUT TRULY SEEING THE MAGIC ALONG THE WAY. Most people are born with two sets of eyes. One set allows us to function through the physics of vision. The others are the eyes of epiphany. These are the ones that allow us to see true light, nuances of motion, and the art in the everyday. It is the duty of the artist, I believe, to help the world see through these eyes. It is not our choice but a calling. My personal calling is interpretation of landscape and seascape. I feel no greater joy than getting it right. Perfect colour, contrast, and composition is my mantra. I strive not for duplication, but translation from the eyes of first sight to the language of the eyes of ephiphany through the strokes of my brush.

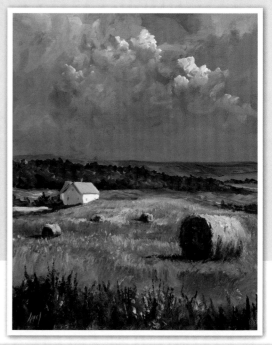

Bales in the Sun
acrylic
14" x 11"

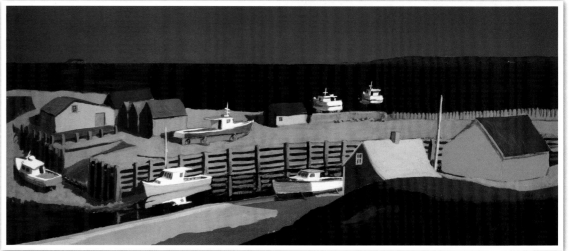

Halls Harbour | acrylic–9.75" x 23"

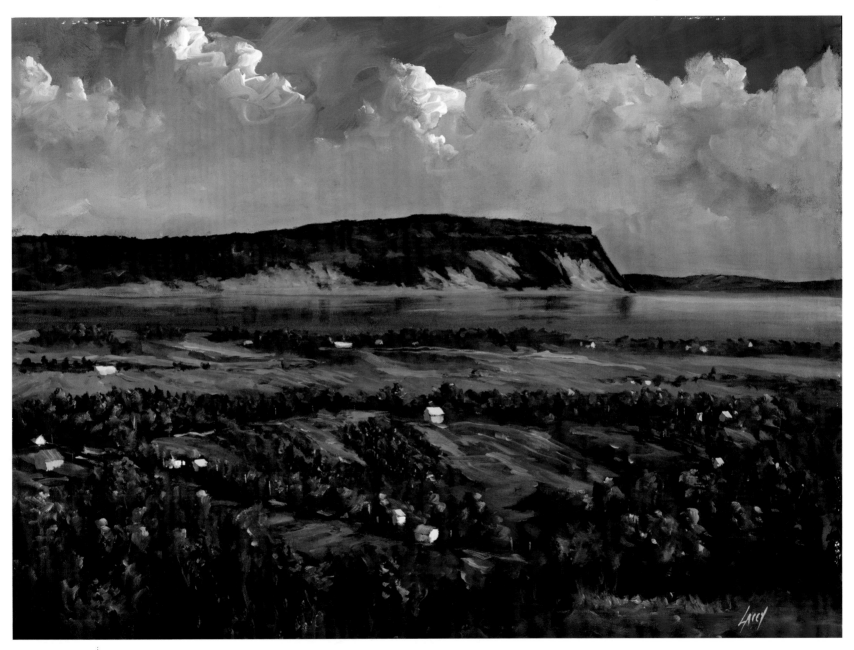

Acadian Morning | acrylic–16" x 20"

Joy Laking

Joy Snihur Wyatt Laking was born in Owen Sound, Ontario, in 1950. She studied fine arts at the University of Guelph, graduating in 1972. Laking has exhibited her work solo at various galleries in Nova Scotia and Ontario, as well as the Owens Art Gallery at Mount Allison University in Sackville, New Brunswick, the Art Gallery of Nova Scotia, and the Royal Botanical Gardens in Burlington, Ontario, and has shown her work in group exhibitions both at home and abroad. She has travelled extensively to Spain, Peru, and other countries on painting expeditions, and continues to experiment with new subjects and media. Her calendars, published from 1998 to 2005, became a yearly tradition in many Nova Scotia homes. Her work can be seen in permanent collections at the Art Gallery of Nova Scotia and the Nova Scotia Art Bank. She has served on the boards of the Robert Pope Foundation and the Society of Canadian Artists. She lives in Portaupique, Nova Scotia, where she maintains her studio and gallery on the shores of the Bay of Fundy.

I LOVE TO PAINT. *For over thirty years I have painted Nova Scotia and captured my view of the world on watercolour paper. I am inspired by the white clapboard houses that are sprinkled along the Bay of Fundy shore, old rocking chairs on porches, flowered curtains billowing in a cottage window, and children playing on the mudflats.*

My studio paintings are developed from on-location paintings, photos, and actual objects and flowers. Sometimes an idea is thought about for a number of years before a painting is started. The actual painting may take several weeks. In all cases the reality in the painting is mine. Often I go in search of the right bed, quilt, or flower garden to create the mood. Strong compositions and a wide range of tonal values making full use of the white of the paper help to make all of my paintings "sing."

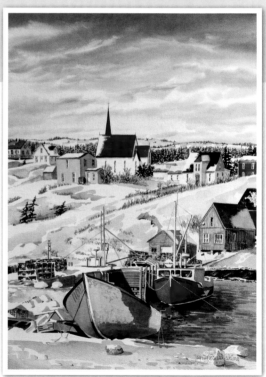

Winter at Peggy's Cove watercolour–21.25" x 14.25"

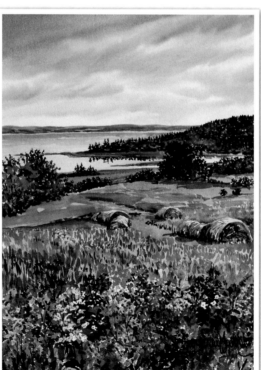

Autumn watercolour–14.25" x 10.25"

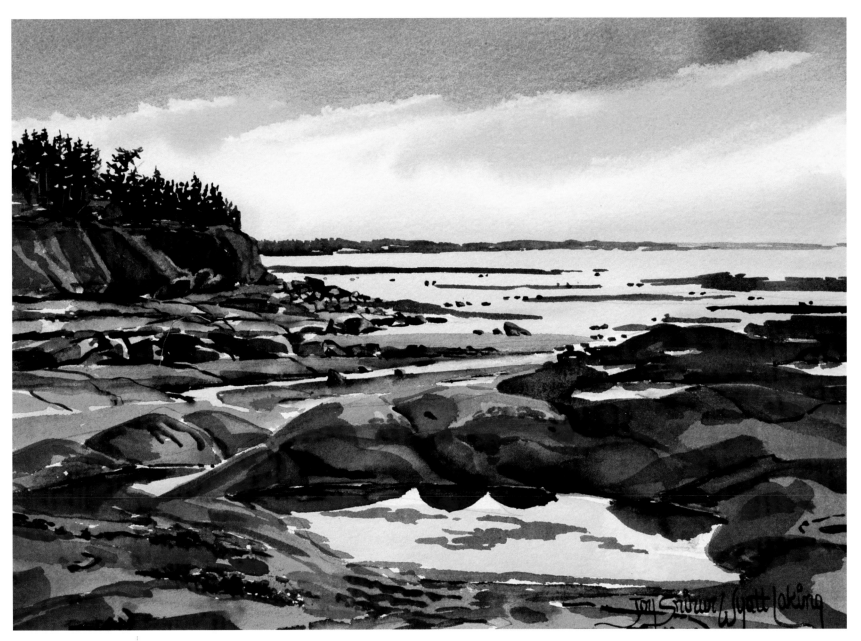

Low Tide at Thomas Cove watercolour–10.25" x 14.25"

Sara MacCulloch

Sara MacCulloch was born in Nova Scotia in 1967. She received her bachelor of fine arts from the Nova Scotia College of Art and Design in 1992, with a major in painting and a minor in art history. She has exhibited with Studio 21 Fine Art since 1996, and has also shown extensively in Toronto.

WHAT I LIKE TO PAINT IS LESS ABOUT WHAT SPECIFICALLY DEFINES A PARTICULAR PLACE, AND MORE ABOUT WHAT MAKES IT SEEM FAMILIAR. It is the feeling of a place that I am after—something that can resonate with the viewer, whether they have been there or not. I work with wet paint. It mixes with the paint that is already on the canvas, it drips, it separates, and the colours blend, often becoming more muted or grey. Sometimes it just becomes mud and I have to let it go—scrape the whole thing off and start over. Even then there are remnants on the canvas that will inform what I put on next. Sometimes it feels like I have no control, and that I don't know what I am doing. I have to work really fast. Whether something comes together or not seems like luck. Sometimes I am sure that a painting is ruined, I leave the room, and when I come back I see that it is actually finished. Other times I can work on the same canvas for weeks and never resolve it.

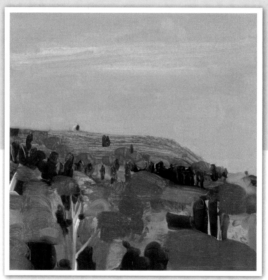

Blomidon Trees | oil on canvas–16" x 16"

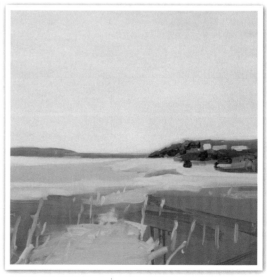

Clam Harbour Beach | oil on canvas–24" x 24"

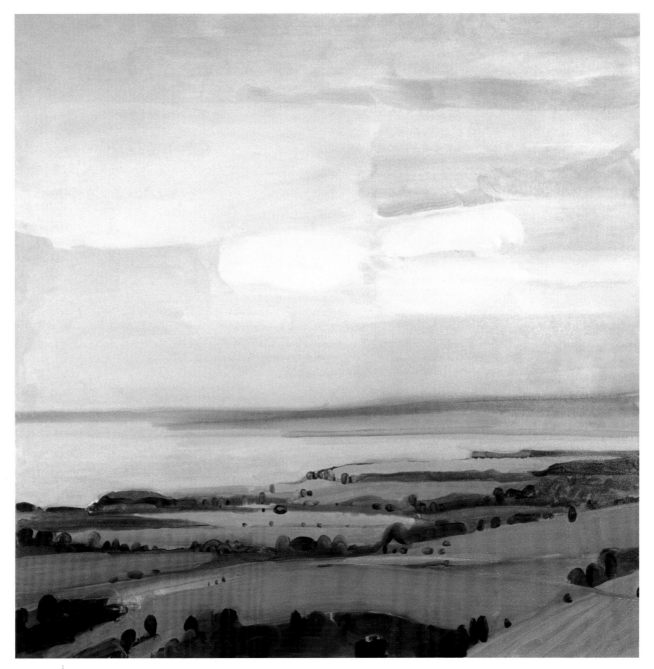

Look-off | oil on canvas–48″ x 48″

Gordon Macdonald

Gordon Macdonald was born and raised in Atlantic Canada. He has focused on being a painter most of his life. At eighteen he moved to Toronto and attended both the Ontario College of Art and the Toronto School of Art. He later moved to New York and studied at the Art Students League, focusing exclusively on drawing. Back in Toronto in the 1990s, Macdonald connected with a group of people studying under the guidance of painter Michael John Angel, who introduced Macdonald to many historical approaches to painting, as well as a solid view of art history. In 1999 he moved back to the East Coast, and after a year in rural New Brunswick, settled in Halifax. Gordon MacDonald is represented exclusively by Argyle Fine Art in Halifax. His work hangs on countless walls, including those of the Canadian Embassy in Israel and the President's House in Dublin.

SINCE MOVING BACK TO ATLANTIC CANADA, I HAVE RECONNECTED WITH MY ORIGINAL INTEREST, AND MADE A LIVING BY LANDSCAPE PAINTING. *I was definitely inspired by many other artists, but it's now important to focus on what I know best—my connection to the Atlantic Canadian landscape. I believe paintings can do a variety of things. Painters can add narrative, shock, ambiguity, and much more to their work. My only goal is to recreate or remind the viewer of a specific, basic experience. If the viewer isn't at least moved in a simple, basic, self-explanatory way, the work will fail.*

An-t-Sabhail Dearg
oil on canvas
18" x 24"

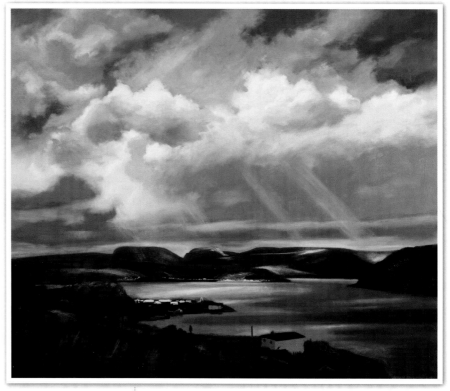

A'Squabadh A Mach Neou | oil on canvas–30" x 36"

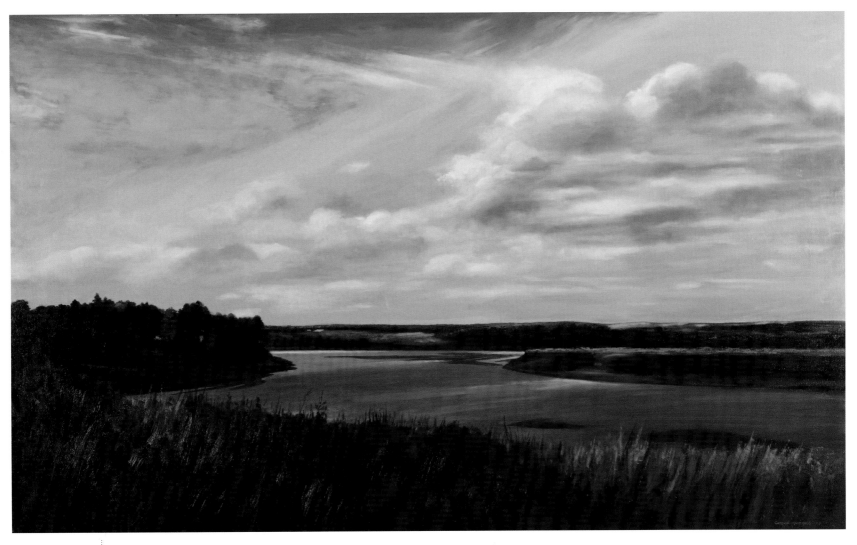

The Forward Tide | oil on canvas–36" x 60"

Kenneth MacIntosh

Kenneth MacIntosh is a soft-spoken resident of Malagash, Cumberland County, on the North Shore of Nova Scotia. Quietly living here all his life, he commands much respect for his art. He studied painting in the fine arts program at St. Francis Xavier University in Antigonish, with further studies under artists DeGarth, Julius Zarand, Donald Pentz, Henry Purdy, Tom Roach, Tom McKay, and Ann Meredith Berry. In 2008, one of MacIntosh's paintings was featured in a calendar published by the Ministry of Health and distributed throughout Nova Scotia. A short feature on some of MacIntosh's work appeared on the CBC Television series, *The Week the Women Went*, in 2009. His work has been displayed at Raven Gallery in Tatamagouche and Veith Street Gallery in Halifax.

LIFE BECAME BRIGHTER AND FULLER WHEN AT THE AGE OF SIXTEEN I DID MY FIRST OIL PAINTING. *It seemed to put in colour on canvas the feeling that I had about the goodness of people. There have been so many wonderful, kind, and helpful people in my life. I hope that my paintings also mirror the optimism of the spirit in people, and the feeling of promise and hope that many of them radiate. I hope that my paintings of the landscape raise concern about keeping our environment and lands preserved and not laid barren. I once heard an art critic say, "Well, that artist only paints a tree," suggesting that the painting was therefore of less value and interest. I say in reply that a tree is more than just a tree—it is history. It gives the breath of life to the planet and so much more. Look for the good in humanity, and it will show in one's painting, and one will experience optimism in life.*

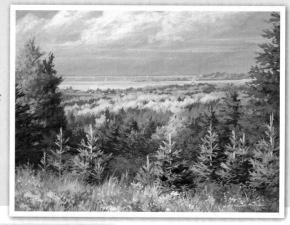

Golden Autumn Glory
acrylic on board
18" x 24"

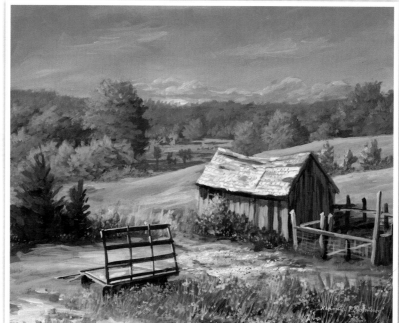

The Hay is in the Barn acrylic on board–16" x 20"

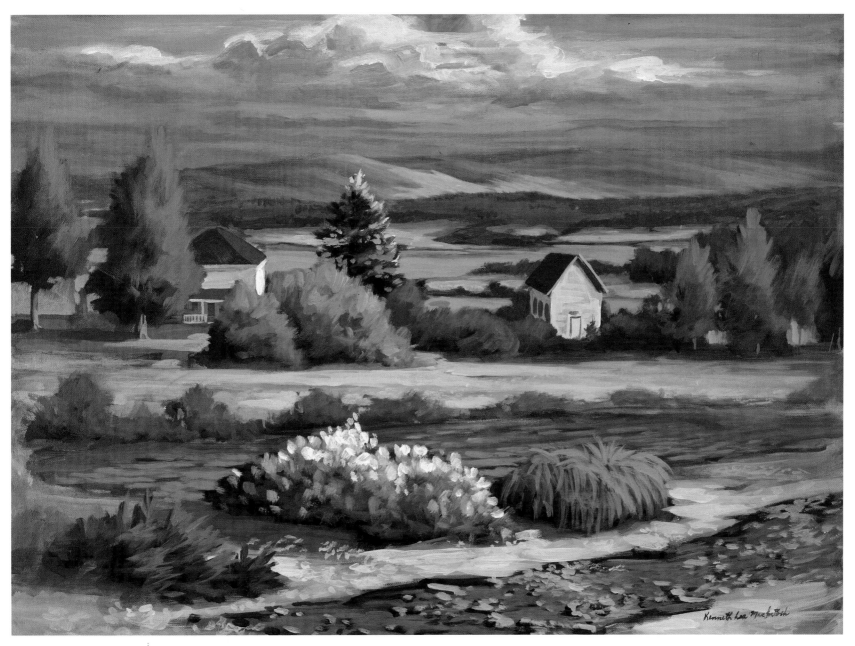

Wonderful Summer Evening | acrylic on board–18" x 24"

V. L. Maclean

V. L. Maclean majored in art at Connecticut College for women and graduated cum laude with a bachelor of fine arts (honours). She also studied figure drawing, woodblock printing, and lithography at the University of Wisconsin. Maclean has lived in Nova Scotia for over forty-eight years. At St. Francis Xavier University, she taught degree and non-degree art in the Fine Arts Department, coordinated the Continuing Education Art Program and was gallery director for the University Art Gallery. Her work is represented by private and corporate collections, and is currently displayed at Zwickers' Gallery in Halifax, as well as various other Maritime art galleries.

HAVING LIVED MOST OF MY LIFE IN RURAL NOVA SCOTIA, MY INTIMACY WITH THE LANDSCAPE HAS BECOME THE INSPIRATION AND ORGANIZING STRUCTURE OF MY PAINTINGS. I constantly strive (and struggle) to create an art work that expresses the energy, light, hue, and timeless quality of each landscape.

Down North oil–24″ x 60″

Pomquet Beach oil–14″ x 36″

Railway Bridge ⏐ oil–28" x 24"

F. Scott MacLeod

F. Scott MacLeod was born in 1954 in Sydney, Nova Scotia. After spending many years in Ontario, he returned to Nova Scotia, to the historic town of Lunenburg, where he pursues his art full-time. As an artist, MacLeod is primarily self-taught. He started painting as a way to free and expand his drawings, but found that once he began, the colour excited his senses in a way that drawing could not. His training has progressed over the years through drawing and painting on location; workshops on colour theory, life drawing, and composition; and continuous reading. He mentions Matisse, Modigliani, and Diebenkorn as influences. MacLeod is an artist whose work is continually evolving. He prefers a strong, simplified style that conveys moods and emotions rather than a controlled, detailed approach. MacLeod's style is immediate and expressive.

I DON'T WORK ON SITE OR FROM REFERENCE. Instead I take in and observe locales and people that interest me. At a later time, these images and feelings crystallize into paintings. My concerns are with light, colour, composition, and design, as well as the physical action of the paint. These images draw from classical forms and abstraction and are presented as a vista or an overview of the Nova Scotia landscape. Working in this way allows me to free-associate and pull off an emotionally charged painting, remembering landscapes seen and experienced.

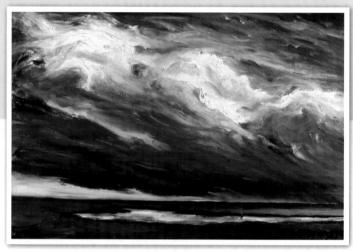

Heaven and Earth
oil
48" x 72"

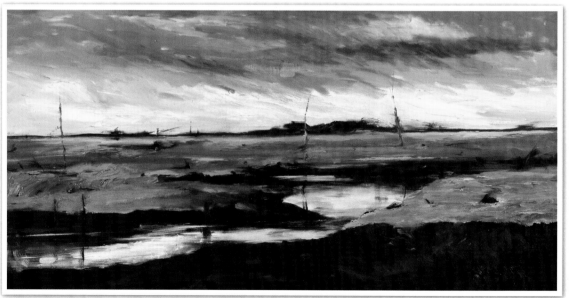

River oil–36" x 72"

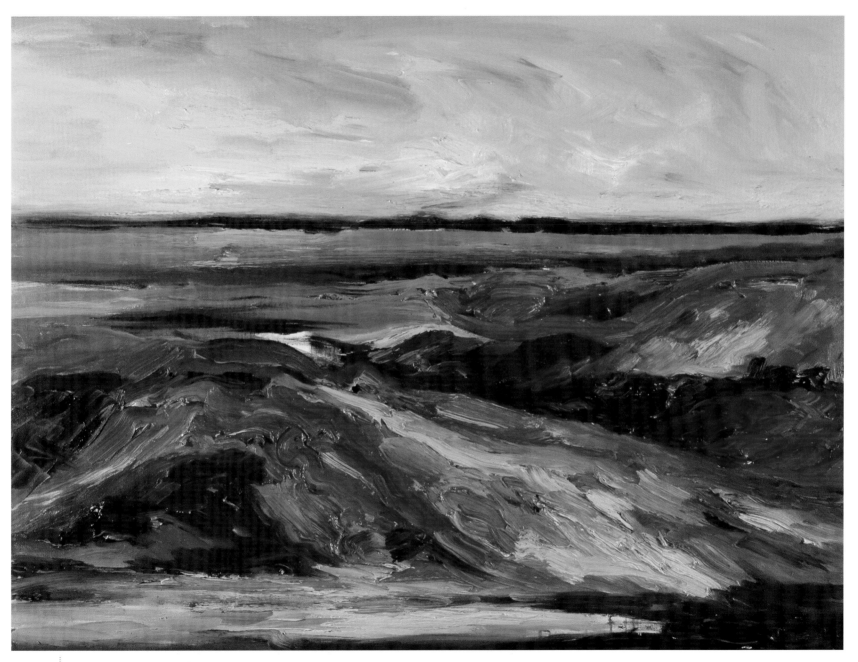

Low Tide | oil–36" x 48"

Cluny Maher

Cluny Maher was born in 1941 in Frampton, south of Québec City. After receiving a bachelor of arts (1963) and a bachelor of education (1964) from Loyola College in Montreal, he taught for twelve years in the public school system. In 1973 he received a bachelor of fine arts from Sir George Williams University at Concordia. In 1977 he moved to Nova Scotia with his family, and a year later settled in Tupperville, Annapolis Valley.

Through my painting I am attempting to express, in a personal way, my reaction to the landscape in which I live. It is my hope that each painting captures a bit of the visual excitement—at times dramatic, but more often of a quiet pastoral nature—that abounds in rural Nova Scotia. The old homesteads and wooden barns and the uncluttered vistas and twisting country roads are a dwindling resource along the eastern seaboard of our continent. My ambition is to apply colour to my paint surface in a spontaneous and immediate fashion, so as to convey and amplify the impact of the landscape and share this experience with the viewer. You must use expressive colour and break borders.
It is the breath of life and it takes a lifetime to master.

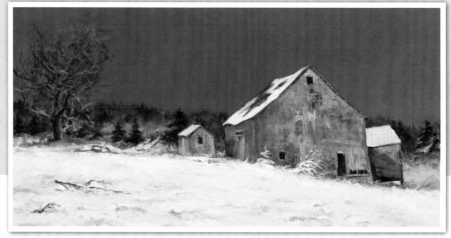

Wonderland
oil
15" x 30"

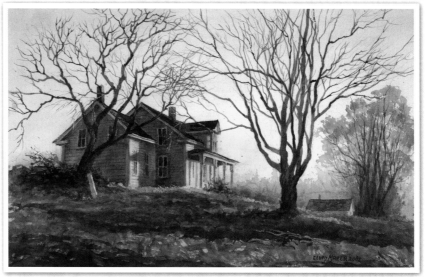

Aiden's Place watercolour–15" x 22"

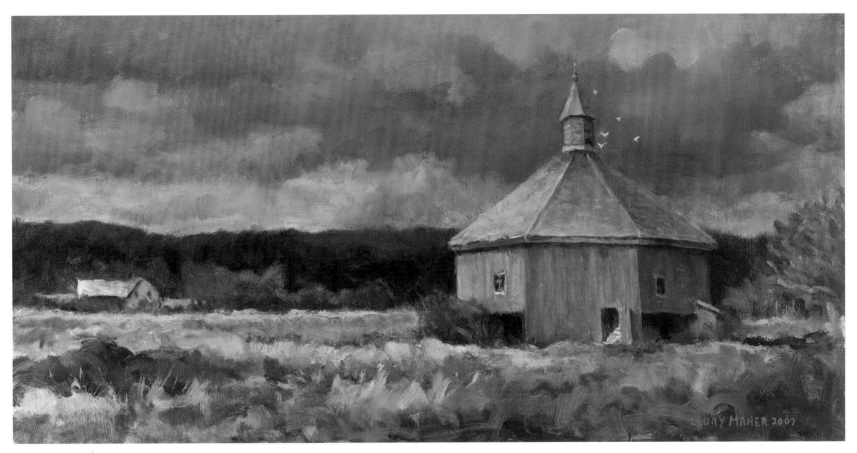

Octagonal Barn | oil–12" x 24"

Shelley Mansel

Shelley Mansel attended the University College of the Fraser Valley for two years in the art diploma program, and completed three years in the bachelor of fine arts program at NSCAD. Mansel has shown in solo, two-person, and group exhibitions in Halifax, Toronto, and Vancouver. Her works have been reviewed and featured in Halifax and Toronto newspapers, and have been published in *Canadian House & Home* magazine and shown on Home and Garden Television.

Mansel's works are held in numerous private collections in Halifax, Toronto, Vancouver, and Germany, and in corporate and permanent collections, including Saint Mary's University in Halifax, and the University of British Columbia Faculty of Dentistry in Vancouver. Her work has also been displayed at galleries, including Gallery Page and Strange in Halifax and Ingram Gallery in Toronto. In 2006, she was part of the selection committee for the Nova Scotia Culture Division's Grants to Individuals program. Mansel was awarded both a creation grant and presentation grant in 2008.

My work spans many sub-themes, which include pastoral, industrial, aerial, and macroscopic landscapes. I often paint Canadian environments, but the specificity of place is inconsequential. I portray landscapes that evoke a universal familiarity. The use of formal elements with respect to colour, composition, and luminosity restrain the landscape to its most elemental forms. The emphasis of space, light, and reflection is integral to my depiction of natural and manufactured environments.

Red Mudflats, 2003 acrylic–24″ x 24″

Old Grove Oxbow, 2003 acrylic–24″ x 24″

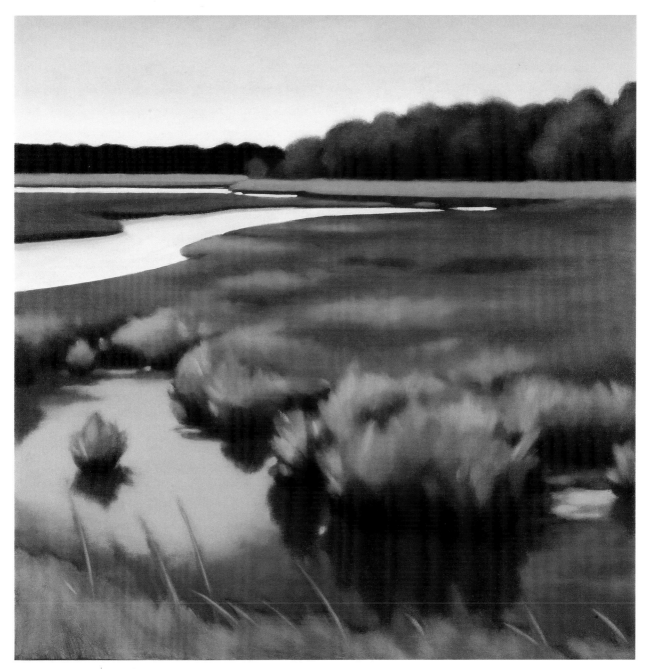

Blue Ellipse, 2003 | acrylic–30" x 30"

Lara Martina

Lara Martina is an artist and writer of French and Italian descent presently living in Nova Scotia. As the daughter of an American military father, she has travelled extensively and has lived in California, Illinois, New Jersey, Massachusetts, New York, Quebec, and France. Summers were always spent at her mother's family summer home in Newfoundland.

Lara studied at the Nova Scotia College of Art and Design, where she graduated with a fine arts degree in 1987, and a degree in fine art and art education in 1989. She holds a research master of arts from Mount Saint Vincent University. Her current work is interdisciplinary in nature with a focus on drawing, painting, and writing. She is currently completing her PhD studies in philosophy of media, film, and communication at the European Graduate School in Saas Fee Wallis, Switzerland.

NEWFOUNDLAND'S WEST COAST HAS STRONGLY INFLUENCED MY AESTHETIC, AND MY PERSONAL IDENTITY. *My collection of life experiences, social encounters, and personal ordeals in that place created a relationship between that island and myself. It has played a large part in determining how I have read my world and how I have given expression to that reading through my art. That association was shaped by what had come before: my maternal family's history, the island's history, and the history of its traditions of craft, song, and story, creating a connection between the sense of self and sense of place.*

Since 1985, I have been developing a new relationship—one with the province of Nova Scotia. The themes and interests that guide my current artistic praxis stem from this immersion, particularly as it relates to "the shore." It has become my habit to tramp the dykes and paint the landscapes between the farmland and marshes.

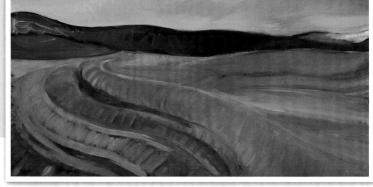

Acadian Straddle
oil on canvas
12" x 24"

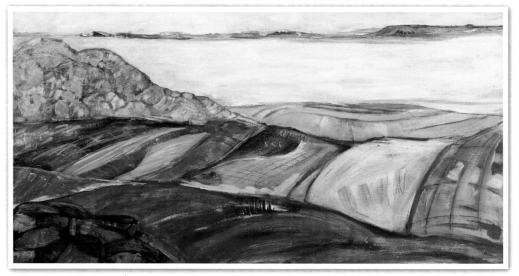

River Mist, Armitage Rd. oil on canvas–12" x 24"

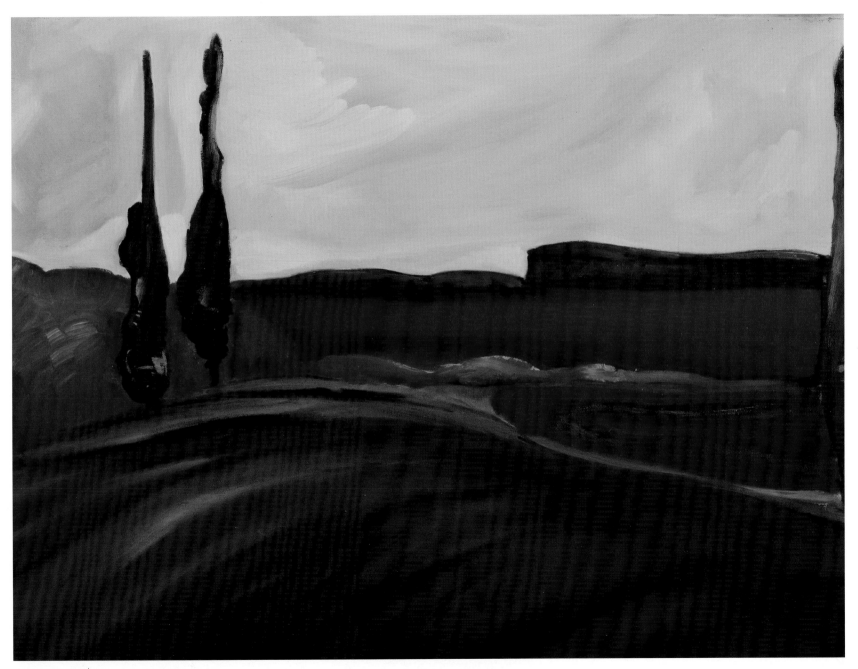

Acadian Elders oil on canvas–18" x 24"

Sharon McKenna

International award-winning artist Sharon D. McKenna was raised in British Columbia, but returned to her roots in Nova Scotia the first chance she got. She has had many exhibitions of her work on both coasts and currently owns the Raven Gallery and Frame Shop in Tatamagouche. Her many accomplishments include carving, woodworking, three-dimensional painting, miniatures, editorial cartooning for the *Pictou Advocate*, and illustrating book covers and magazine articles.

All the Best
Sharon McKenna

FROM AN EARLY AGE, ART HAS BEEN A WAY TO EXPRESS, TO COMMUNICATE THE WAY I FEEL FOR THE THINGS AROUND ME, TO RECORD HISTORY, TRADITIONS, GREAT LOVE, THOUGHTS, AND EMOTIONS. *My paintings are a visual way of storytelling. Each painting has a story behind it. I like to think that they speak, that you can become one with the picture. I have to have a connection with the subject I am painting to give it life, to capture its spirit, so that the painting is not flat, but has an inner presence. Even with my miniature islands, I like to imagine who lives there. I walk inside the houses, in my mind, so that they become familiar, like a pair of old shoes. A part of me is in everything I do. They are windows to my world, a reflection of how I see it.*

Kelly Mountain Foxes | acrylic on paper–24" x 34"

Afternoon Reflections acrylic on paper–9" x 14"

Barbara McLean

Barb McLean is a graduate of Sheridan College (honours in graphic design) and NSCAD (major in fine arts). She is currently the visual arts representative for the South Shore Region of Nova Scotia. In the fall of 2005, after three years spent painting and teaching English in Korea, she returned to her home near Chester, Nova Scotia, re-established her studio, and joined Peer Gallery in Lunenburg. Her work has also been displayed at Art Choices Gallery in Lunenburg and at the Art Sales and Rental Gallery in Halifax.

ALTHOUGH I AM NOW WORKING LESS IN THE SUBTLY MODULATED TONES THAT CHARACTERIZED MY PAINTINGS IMMEDIATELY AFTER MY RETURN FROM KOREA, I AM STRIVING TO RETAIN THE BREVITY AND THE INCISIVENESS THAT APPEALED TO ME IN EASTERN INK-WASH PIECES. *My goal is to combine that Asian directness with an "on-the-edge-of-control" energy often found in contemporary Western painting. As I continue to concentrate on the intentionality and economy of brush stroke, I have found that colour has also become very important to me. I use colour as a compositional element and for its emotional import, rather than for its trueness to nature.*

I paint primarily in oils on canvases that I build myself. Although I enjoy working "non-objectively" (or without a literal subject), and I sometimes paint figuratively, the largest part of my work is abstract landscapes. These paintings evolve from combinations of sketches done on site, small painted studies done either on site or from photographs, and lastly and probably predominantly, memory and intuition.

Whatever the image source, I feel paint and how that paint is applied are key to my realizing a successful piece of work. I hope that my paintings convey to the viewer a sense of energy and potential that I feel is inherent in landscape.

Boreal Forest
oil on canvas
22" x 16.5"

Describing Landscape I, diptych | oil on canvas–48" x 72"

Describing Landscape II, diptych oil on canvas–48″ x 72″

Shelley Mitchell

Shelley Mitchell worked as an architectural draftsperson for many years before returning to the Nova Scotia College of Art and Design, where she earned her bachelor's degree in painting and art history. Since then she has shown professionally in both group and solo exhibitions in Nova Scotia, Ontario, and Maine. Her work is represented in the Canadiana Fund State Art Collection in Ottawa, as well as many private and corporate collections in Canada, the United States, and Germany, and displayed at galleries such as Amicus Gallery in Chester and Argyle Fine Art Gallery in Halifax.

The physical presence of Atlantic Canada, with its ever-changing atmosphere and diversity of land and sea and shore, moves me to paint continuously. Each part of the day and every change in the weather give me inspiration. I have painted all my life and will continue because I want to share the serenity and peace that I find in these places. I try to express that moment of tranquility or excitement in each painting so that it becomes part of the viewer's experience. Sometimes the key to the idea is not in the overall composition, but in a detail of the work. For example, a particular boat is not important, but the surface of the water upon which it rests is critical. Which tree is chosen does not matter, but the quality of the air around it does. I discovered as a child the wonderful fluid medium of oil paint and have never found a more satisfying material to use, although I enjoy working with oil pastels on occasion and the immediacy of watercolour is useful for sketching. I feel grateful every day to be a part of the continuing dialogue of art.

Mahone Bay
oil on canvas
30" x 36"

Pine at Green Bay ┊ oil on canvas–36" x 36"

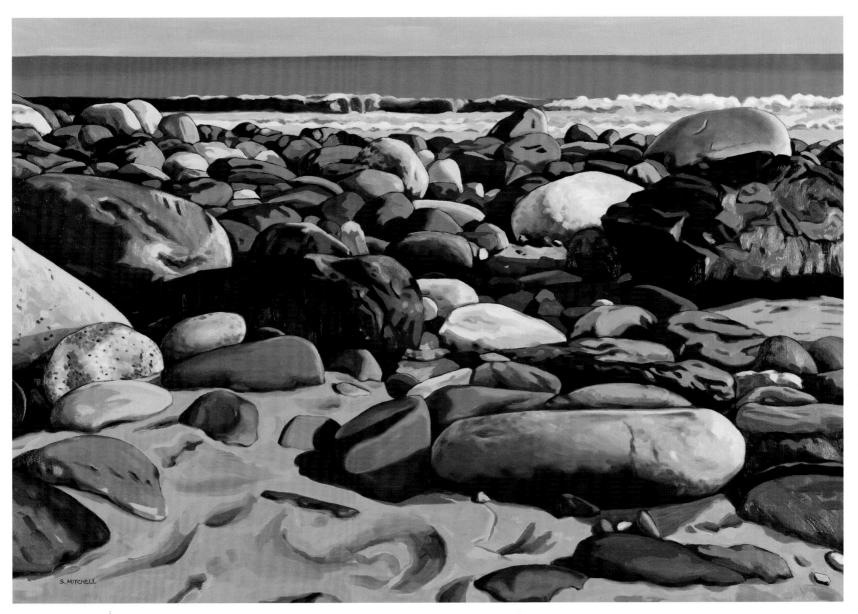

Hirtle's Beach Rocks | oil on canvas–33" x 48"

Carol Morrison

Carol Morrison has had solo exhibitions at the Anna Leonowens, Craig, and VANS Corridor galleries, and the Rossignol Cultural Center in Liverpool. Her work has also been chosen for juried shows of the Society of Canadian Artists and the Canadian Institute of Portrait Artists in Red Deer, Calgary, and Montreal, as well as at the Keenan Center in New York. Her paintings can be seen in the Art Sales and Rental Gallery in Halifax, ArtChoices at Sue Beaver's Place in Lunenburg, Utata Gallery in Windsor, and the ADJA gallery in Liverpool. Morrison's portraits are installed in the IWK Health Centre, the Queen Elizabeth II Health Centre, the Halifax office of the Canadian Institute for the Blind, and in numerous private collections. The Nova Scotia Art Bank bought her work in 2005, 2006, and 2009, and in 2005 she received an award for an emerging artist from the Elizabeth Greenshields Foundation. In 2008 Morrison received a creation grant from the province of Nova Scotia to work on a project for Amnesty International, painting victims of injustice.

As a biologist and an artist, I am very interested in the world around us and am fascinated by the constantly changing appearance of the lakes, woods, brooks, and fields. Tom Thomson's small panels, in which he interprets nature with vigorous and colourful brush-strokes, are my main inspiration for plein-air *paintings. However, the grandeur and beauty of some of the scenery around this province are awe-inspiring, especially when shrouded in mist or accompanied by thunderous cloud formations. I felt that these scenes could only be expressed in larger paintings, using a combination of* plein-air *paintings and photographs for my inspiration. I found that I kept thinking of paintings by great masters that show an awe of nature, such as the grandeur of the cliffs seen through the mist in* Sunrise on the Saguenay *by Lucius O'Brien, or the cloud formations in many works by Turner.*

Smokey from Ingonish Harbour oil on canvas–24″ x 72″

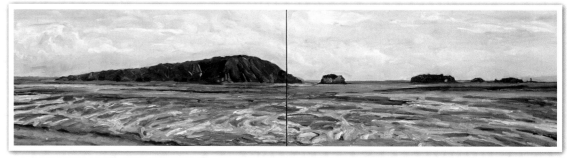

Five Islands **(diptych)** oil on canvas–18″ x 72″

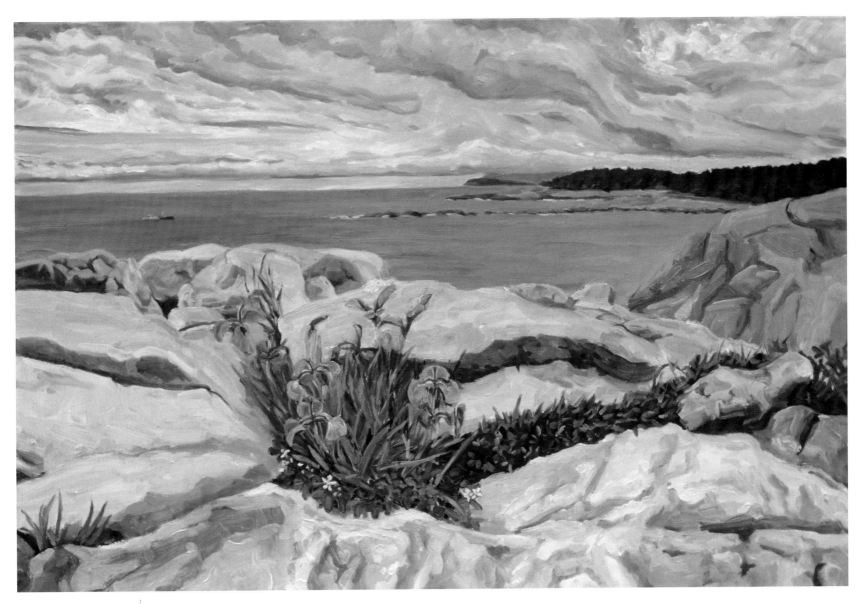

Smokey from Green Cove | oil on canvas–24" x 36"

Susan Paterson

Susan Paterson was born in Halifax, Nova Scotia, in 1958. She attended Mount Allison University in Sackville, New Brunswick, and received her bachelor of fine arts degree in 1980. She did further study at Byam Shaw School of Art in London, England; Nova Scotia College of Art and Design in Halifax; and the School of the Museum of Fine Arts in Boston, Massachusetts. Paterson has exhibited extensively throughout Canada and has work in collections all over the world, including Husky Oil, Bank of Detroit, Art Gallery of Nova Scotia, Olympia and York Developments, Mitsu Taiyo Kobe Bank, Magna International, and K. K. Sakai in Tokyo, Japan. In 2008, her work was featured in "Master Painters" in the *International Artist* magazine. Early in her career she received a grant through the Elizabeth Greenshields Foundation. Paterson is a member of the Canadian Society of Painters in Water Colour. Her work has been displayed at many galleries, including Fog Forest Gallery in Sackville, New Brunswick, Amicus Gallery in Chester, and Details Past and Present in Charlottetown.

I HAVE LIVED IN NOVA SCOTIA NEARLY ALL MY LIFE AND HAVE ALWAYS BEEN INSPIRED BY THE LANDSCAPE AROUND ME. In travelling around the province or looking out my front window, there are many things that attract my attention: interesting trees, waves, farmhouses, and almost anything covered in a blanket of snow. My palette is generally very subdued with a lot of blues and greys, but with strong dramatic light—whether it be the first light of the day giving the subject warmth and colour, or the lively strong shadows of a little later in the day—helping to define the shape of a rock or the depth of a track in the snow. Focusing on the detail of a scene helps me to really study and know the subject, and hopefully to show the viewer the beauty of an everyday scene that, too often, we don't take the time to enjoy.

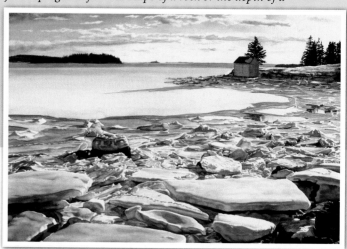

Breaking Ice
watercolour
18" x 27"

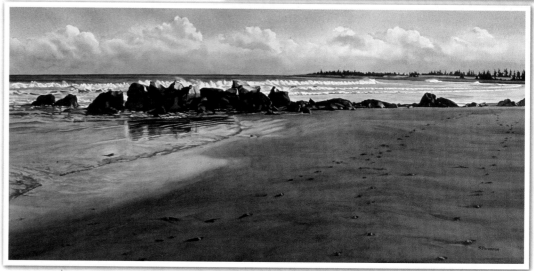

Rock Ridge | watercolour–17" x 36"

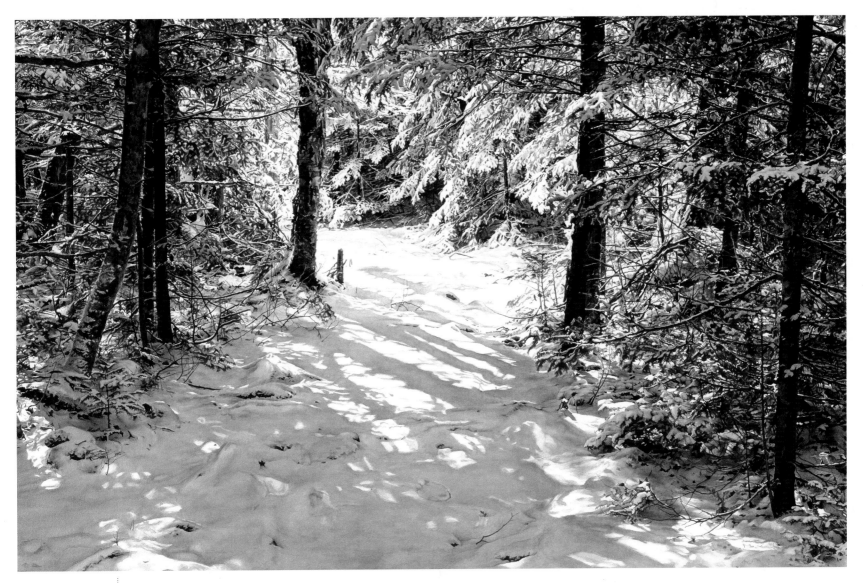

A Walk in the Woods | watercolour–28″ x 42″

Leonard Paul

Leonard Paul, an international First Nation Mi'kmaq artist from Nova Scotia, was born in Halifax in 1953, and currently resides in Calgary, Alberta. He studied in the bachelor of fine arts program at NSCAD, and majored in political science and art history at Acadia University, graduating with a bachelor of arts in 1991. Paul is a full-time visual artist, although he recently spent time as acting director of Indian Brook R.O.C.K.S., an arts/cultural program in Indian Brook First Nation, dedicated to promoting cultural arts among youth. Since 1994, Paul has been the owner and president of Fox Trail Editions Incorporated. His artwork has touched the lives of many dignitaries: Her Royal Highness, Princess Anne of Great Britain opened an exhibition of his work at the Norman Mackenzie Art Gallery in Regina. In 1996, External Affairs and Industry Canada's Aboriginal Business Canada selected Paul's company as a Canadian representative at the world trade show in Frankfurt, Germany. In 1991, he received national exposure on television, when he was selected as one of the primary artists for *Kwa'nute*, a film produced by the National Film Board. In 1998 and 1999, CBC Television broadcasted the life and work of Leonard Paul as one of their themes for a unique project, *Artspots*.

To name a few, I enjoy the writings of Robert Frost, Henry David Thoreau, and William Wordsworth. *Their writings helped me understand my emotions and how to interpret my feelings when I create. In a way, my father, Noel Cope, was teaching pantheism whenever we went hunting or fishing. I felt peace and sensed order in nature. Thus, a landscape painting is a jumble of emotions that I convey on canvas, not just a pretty picture. I paint with a pencil and draw with a brush.*

I've enjoyed painting rivers since I was able to start walking. My father was a Mi'kmaq traditional hunter and trapper, and I was his sidekick toddler who made a lot of noise in the thickets—chagrin! Now, Pam and I continue to search and explore rivers and brooks throughout Nova Scotia. She is my comrade and photographer who shares the same enthusiasm with me. I find pleasure looking over farm fields. Fields are noisy with the beautiful sounds of songbirds and the winds sweeping over my face.

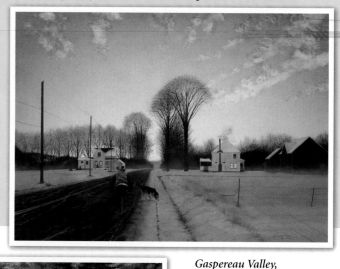

Gaspereau Valley, Newspaper Boy
watercolour
24" x 30"

North River | acrylic on gessoed Masonite–12" x 22"

Too Close for Comfort | watercolour–24″ x 28″

Don Pentz

Don Pentz received his bachelor of fine arts from Mount Allison University in 1966, and master of fine arts from the University of Regina in 1979. He was also privileged to spend a summer at the Banff School of Fine Arts. His work has been exhibited in galleries across Canada and as far afield as England, Japan, France, and the United States. In addition to doing studio work, Pentz enjoys working on location with oils or watercolours. This occasional change to *plein-air* painting allows for a more spontaneous approach to making art, and is a refreshing release from the more controlled studio environment.

THE CREVASSES, STAINS, SPLITS, QUARTZ VEINS, AND TEXTURE OF NOVA SCOTIA'S GRANITE FORMATIONS HAVE BEEN A PART OF MY LIFE SINCE CHILDHOOD. *Who knows what impressions or data were gleaned and locked away in the back of one's memory bank while clamouring over these massive outcrops or looking at the suggested imagery within patterns of stain or lichen. This accumulation of sensory and tactile information, this composite of mass, line, and texture, is what currently informs my work—an ongoing series of paintings all under the same designation: Ancient Landscape.*

In this body of acrylics, the landscape has been reduced to a simplified format—a sky area over a landmass. It is a land streaked and stained with colour, but also scraped and gouged, as are the coastal and inland geological forms of Nova Scotia. It is these combinations of colour and texture that often catch my attention when trekking the land.

There is no pre-plan or attempt to portray particular locations. The paintings in the Ancient Landscape series are landscapes of the imagination, suggested by the working of paint into the textured canvas surface, but influenced by the natural world of shoreline rock or inland barren. Depending on their own travel experience, viewers of my work are free to interpret or see whatever landscape is suggested to them by the painted image.

Ancient Landscape #105
acrylic on canvas
72" x 60"

Ancient Landscape #61 acrylic on canvas–36" x 60"

Ancient Landscape #104 | acrylic on canvas—36" x 60"

Carolyn Poel

Carolyn Poel's birthplace was Denver, Colorado. A few years later her family moved to Michigan. From the time she was nine until she graduated high school she lived in Japan. Her formal education in art began with courses in oil painting throughout high school. She had an art major at Calvin College in Grand Rapids, Michigan, completing a bachelor's degree in liberal arts. Following college, she taught elementary school in Iowa before immigrating to Canada with her husband in 1968. Their two daughters were born in Nova Scotia. She turned to a full-time art career in the early 1980s. For a few years she taught oil painting in continuing education classes and in her home studio in Prospect Bay. She has shown her work in various Halifax galleries and in Montreal.

NOVA SCOTIA IS MY ADOPTED HOME. *I was born in the United States and spent my most formative years through the end of high school in Japan. This experience in Japan gave me an appreciation, even love, of landscape as an art form. My formal university training in the United States pushed in the directions of abstract, non-objective expressions of art. Living in Nova Scotia since 1968—spending much of that time on the shores of Prospect Bay—has given me an appreciation for realism in landscape that I could not ignore. The coast of Nova Scotia—its rocks, evergreens, wildflowers, and water—mirrors the aesthetics of the natural environment of Japan. This subject matter captured my interest for artistic expression. Every pattern and all the many details fascinate and compel me to reflect my creator's glory and to share them in my paintings.*

Pathways on Granite
oil on canvas
20" x 36"

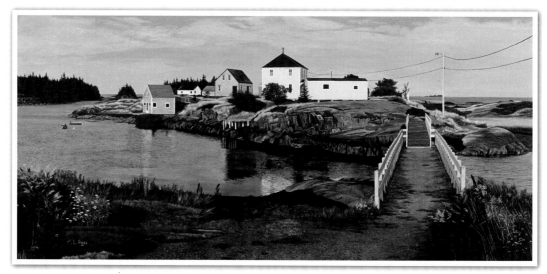

East Stonehurst Island oil on canvas–20" x 43"

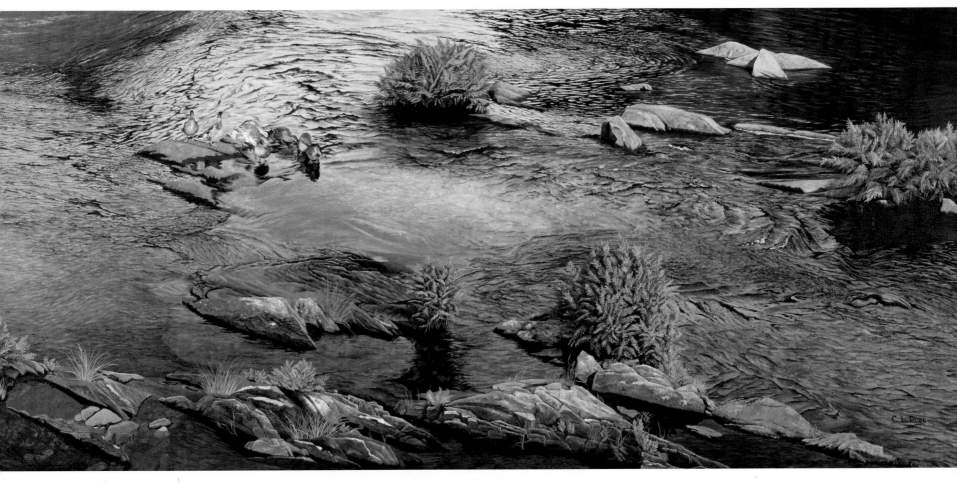

Ducks on the Medway oil on canvas–20" x 45"

Zehava Power

Zehava Power was born and raised in Israel, and moved to Canada in 1986. She's a self-taught artist, and has been painting for about twenty-three years. Influence for her work comes from the French Impressionists, the Group of Seven, and other contemporary artists. Inspiration comes from people and the scenery that surrounds her. She is interested in scenes that bring out the beauty and aesthetics of the otherwise mundane. She strives to capture and communicate that sense of joy to her viewers through her trademark flamboyant use of colour and loose painting style.

MY LOVE FOR COLOUR PLAYS A BIG ROLE IN MY DRIVE TO PAINT. Observing interacting colours and how they relate to overall compositions has become an integral part of my perception. Having moved across the sea, from Israel, I made a transition between different cultures, climates, and light conditions. My fascination with a range of subjects led me to a versatile and diverse painting style. Different characters, their gestures and expressions, inspire me. Both my homeland and Canada are "melting pots" and offer a great selection of ethnicities. I crave light and warmth, living in this northern hemisphere, and painting Mediterranean scenes helps to soothe that need and make me happy. I strive to capture and communicate that sense of joy to my viewers. I love the thought of my art being a mood-changing object, whether energizing or meditative. To me a successful painting not only shows beauty, but evokes a sense of wonder and well-being in the viewer.

Lake Serenity | acrylic on canvas–24" x 30"

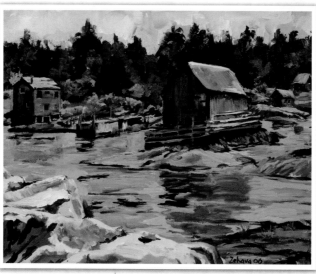

Blue Rocks, Nova Scotia | acrylic on canvas–11" x 14"

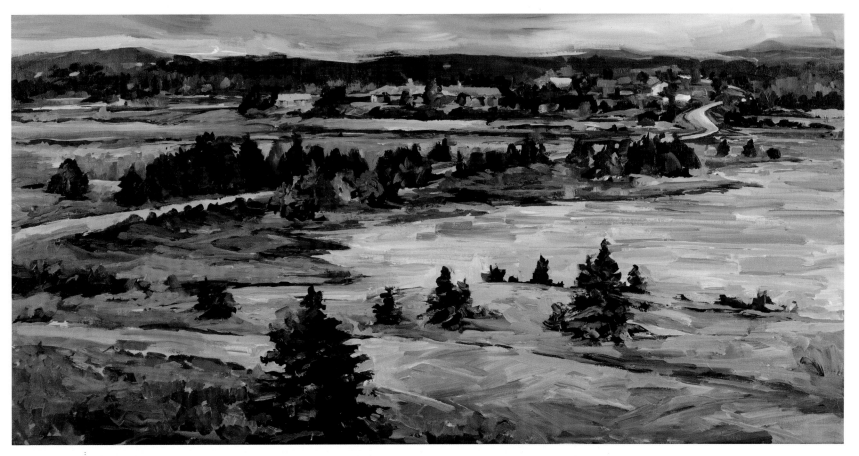

Lawrencetown | acrylic on canvas–18″ x 36″

Alice Reed

Alice Reed was born in Toronto, Ontario, and had an early grounding in visual art. Time spent at her family cottage in Muskoka profoundly influenced her relationship with nature. Reed holds a bachelor of fine arts degree with distinction from Mount Allison University in New Brunswick. She has lived as a professional artist in Nova Scotia since 1980. A member of the Canadian Society of Painters in Water Colour, her paintings are found in collections worldwide, notably in the Royal Collection of Her Majesty the Queen in England. Reed is an honorary director of the Nova Scotia Nature Trust and received a Nova Scotia Environmental Award for her exhibition, Sacred Worth.

NATURE HAS BEEN MY INSPIRATION SINCE I FIRST PICKED UP A PAINTBRUSH. *As a child I'd tag along with my mother, Enid Reed, also a landscape artist. I came to enjoy exploring wilderness, whether on foot or in a canoe or kayak, and began to express my love of these untrammelled woods and shorelines through my own watercolour paintings. The harmony and balance of nature has been a conscious theme throughout my work. I try to convey the sense of wonder and respect I feel upon experiencing old trees towering overhead or sunlight sparkling on water. Nature embraces me and I attempt to do the same.*

I'm increasingly troubled by the careless, greedy, and virtually unabated destruction of nature by human actions, whether clear-cutting forests, draining wetlands, or polluting waterways and air. Wild places are habitat for life forms in addition to our own, and deserve protection for their sake and ours. I hope that my artwork inspires viewers to share responsibility for their survival, and that it continues to be a celebration of nature.

Elder Woods
watercolour
101.5 x 47 cm

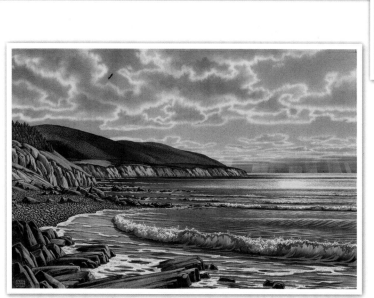

Dancing In The Light | watercolour–27.9 x 41.8 cm

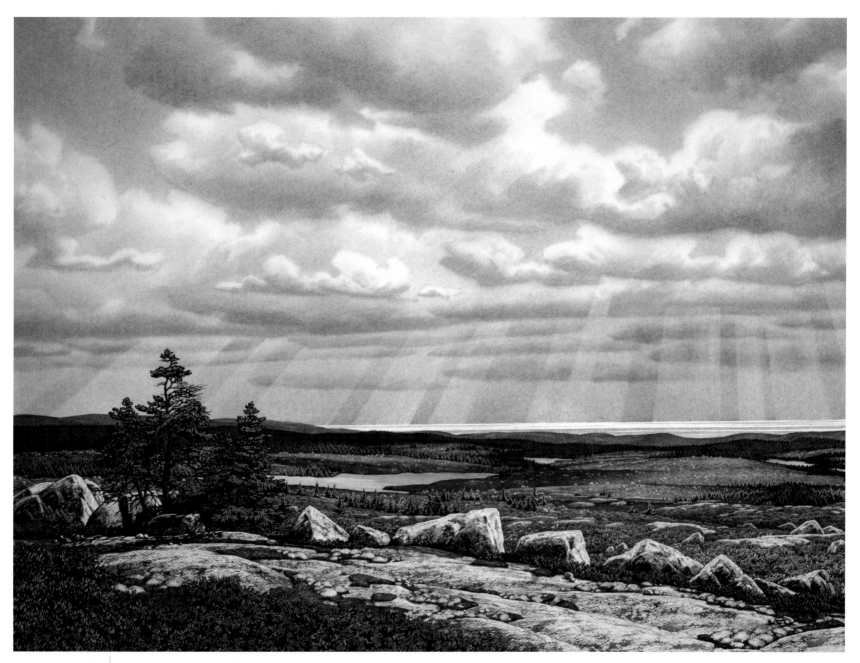

October Blueberries watercolour–57.1 cm x 78.7 cm

Steven Rhude

Steven Rhude was born in Rouyn-Noranda, Quebec, in 1959. He studied at the Ontario College of Art and Design in Toronto, graduating in 1983 with honours in drawing and painting. Rhude's early work was inspired by everyday life, and included portraits of his wife, interiors, and landscapes of the southern Ontario countryside. He progressed from pictorial realism in the 1980s to develop a distinctly Maritime representation in the 1990s. In 1990, Rhude and his wife, Simone, moved to Fox Island Main, Guysborough County. It was there, in relative isolation, that Rhude developed the realistic and colourful style he is known for today.

I HAVE TAKEN NUMEROUS TRIPS THROUGHOUT NOVA SCOTIA, MADE DRAWINGS, TAKEN PHOTOGRAPHS, INTERVIEWED PEOPLE, AND MADE NOTES. Back in my studio and armed with this material, I've continued to explore objects and architecture that reflect the utility of the coastal mind. I confess to a quest for a grain of the bigger picture in the small, the universal in the local. I use this premise to identify with the social and poetic nature of two concurrent art practices: modernism and realism as they move into the twenty-first century.

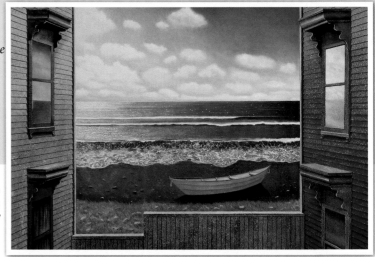

Between Houses
oil on canvas
40″ x 60″

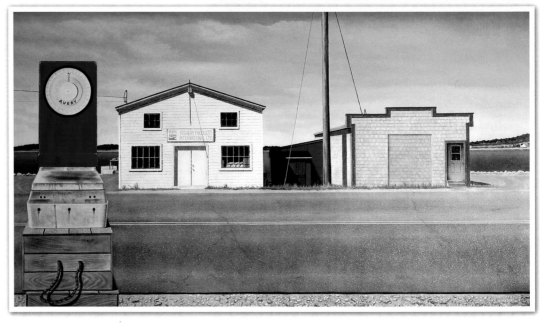

Fish Scale in Riverport oil on canvas–40″ x 66″

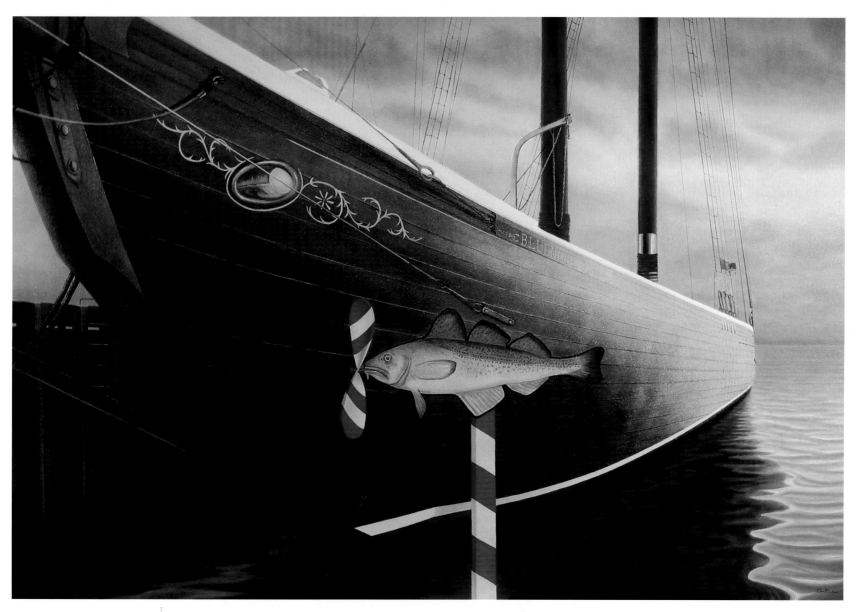

The **Bluenose II** *and* **Whirlygig** | oil on canvas–48″ x 60″

Twila Robar-DeCoste (SCA) of Aylesford is a self-taught artist and illustrator, living and working in the Annapolis Valley. She holds bachelor's degrees in science and education, and a master's degree in science from Acadia University. She has illustrated eighteen books, mostly on natural history, and co-authored two books on local history. She has taught painting classes and workshops for many years. Her work was selected for the 2004 and 2005 Canadian Lung Association Easter Seals campaigns. Windsong Studio and Gallery is located in her 1866 home. She has participated in the Studio Rally since 1993, and her work has been shown at many galleries, including the Art Sales and Rental Gallery in Halifax, At the Sign of the Whale Gallery in Yarmouth, and the Raven Gallery in Tatamagouche.

I AM INSPIRED BY THE BEAUTY AND DIVERSITY OF NATURE, AND THE LANDSCAPES AND SEASCAPES THAT ARE ITS INTEGRAL PART. Here in the Annapolis Valley we are so richly blessed in so many ways. We have a bountiful harvest of wonderful visual delights. There is so much to see, sketch, and paint around every bend of these old valley roads. Our close proximity to the Fundy shore provides yet another multitude of painting opportunities. It is my hope that my artwork will convey some of this to others. I hope that people will learn to love and respect nature and the landscape and value it as I do. I want people to rejoice in the soft warm light of late afternoon on our rolling farmlands, ache at the moodiness of the bay, and feel the heartbeat of a chickadee. Perhaps I can encourage that with my work.

Fall, Red Maple
acrylic
11" x 14"

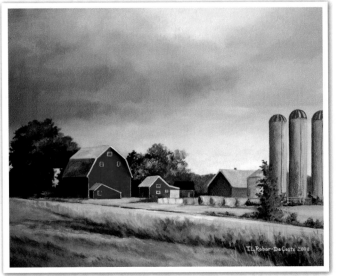

Storm Gathering, Valley Farm acrylic–8" x 10"

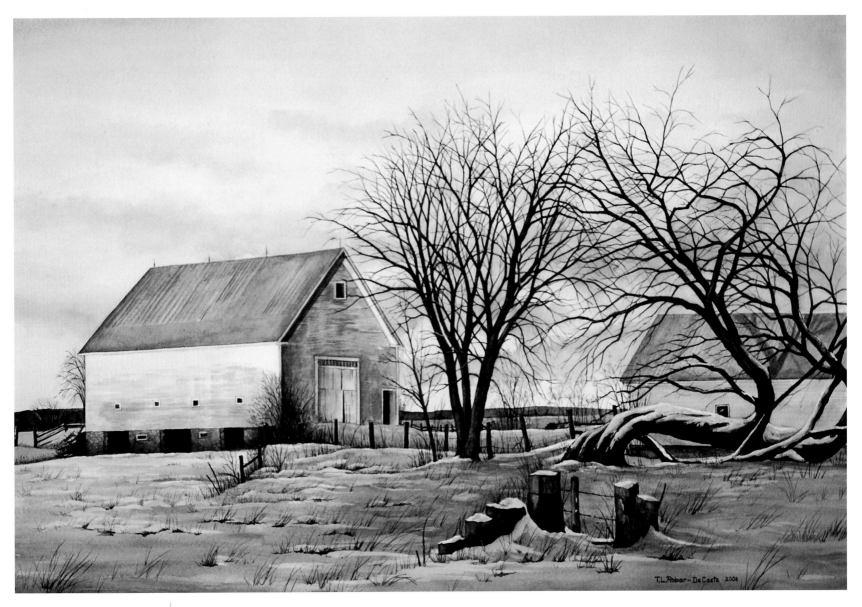

Winter Afternoon, Nichols Farm | watercolour–15" x 22"

Bill Rogers

Bill Rogers is an elected member of the Canadian Society of Painters in Water Colour and is currently the Atlantic regional director. He is also a signature member of the Transparent Watercolor Society of America and the Société Canadienne de l'Aquarelle. Most of his landscapes are done *plein-air*, where his aim is to capture the light and ambiance of a place and filter this through his mind using design principles.

My WORK IS A REACTION TO THE LANDSCAPE, PEOPLE, THEIR ANIMALS, OR ANYTHING THAT INSPIRES ME. *For smaller pieces I work on location most of the time, and I feel this gives me the knowledge and experience to accurately translate photos and sketches into larger studio work. I feel that painting on location allows me to see into the shadows and record the subtle nuances that a camera misses. This makes the work authentic and my choices of subject, arrangement, and emphasis make it uniquely mine. When painting I try to reach a state of mind where my reactions are intuitive, and when I do, my best work occurs. Photographic accuracy is not my aim, but capturing the essence or spirit of a subject is. Watercolour makes up my present means of expression, although I have also worked in other media. The spontaneity of watercolour seems to capture the aspect of a thing that best expresses my reaction to it. I hope this experience and feeling is passed on to the viewer.*

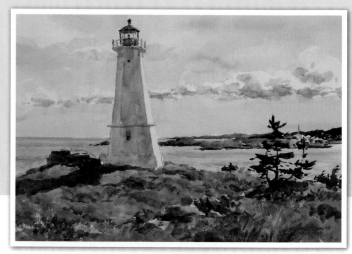

Louisbourg Lighthouse
watercolour
14" x 21"

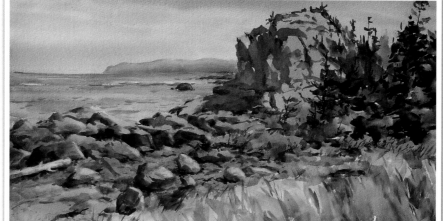

Frenchman's Barn | watercolour–12" x 21"

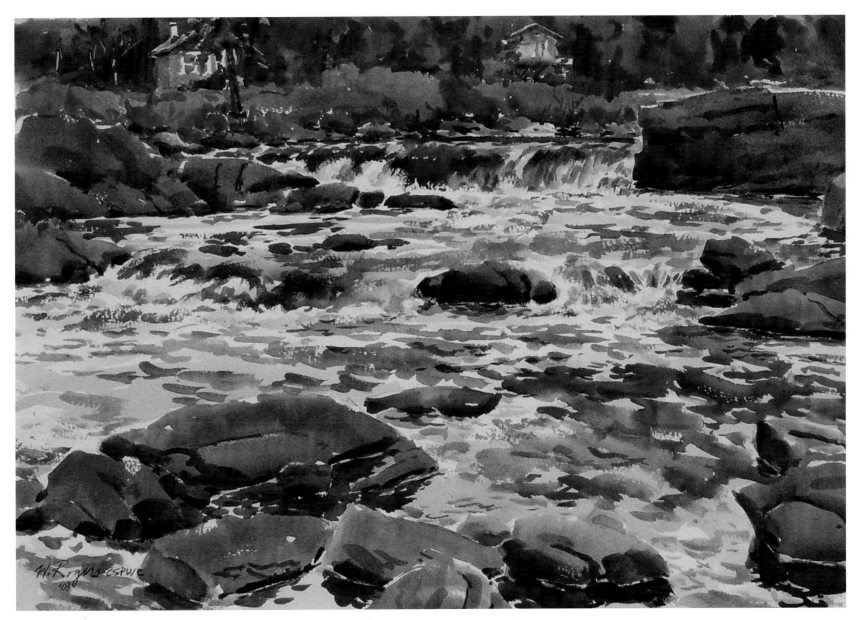

Liscomb River | watercolour–14″ x 21″

Richard Rudnicki

Raised in the Ottawa Valley, Richard Rudnicki was a child inventor with a vivid imagination. He studied nature and began drawing at a very young age. He made up his mind about what was right and, often against the wishes of others, went his own way. Rudnicki chose to study fine art and graphic design, and as an idealistic young man, became resident artist with CUSO. A short time later he started a graphic design firm, which grew into a successful marketing and advertising company. With a growing family, he designed and built a log house.

In time, Rudnicki grew tired of the stresses and restrictions of the commercial world. He sold his company to build a new career as a visual artist. Reaching deep inside himself he rediscovered his creativity. To be close to nature, to be in touch with his feelings, to be happy, healthy, and productive, he returned to his first love, drawing and painting. Rudnicki teaches figure drawing and portraiture, gives workshops on various techniques, and makes presentations about art and the process of becoming an artist. He lives in Halifax.

My love for the beauty, subtlety, and harmony of the natural world engages me. Things physical and of the spirit are the fertile grounds for my creative explorations. With my drawings and paintings I assert a way of life, a way of seeing things, a way of learning, understanding, growing. It's a way to reach others. My approach to the craft is subjective; it's on an emotional level, empathetic and sensitive to subtle undercurrents that I use to provoke instinctive, sometimes non-rational, creative decisions that feel just right.

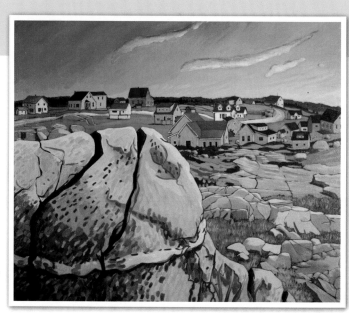

Peggy's Cove, No Lighthouse
acrylic on canvas
20" x 24"

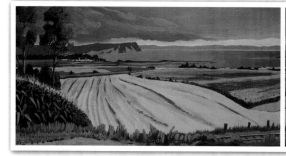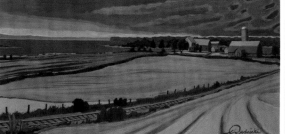

Horton Landing (diptych) | acrylic on canvas–12" x 48"

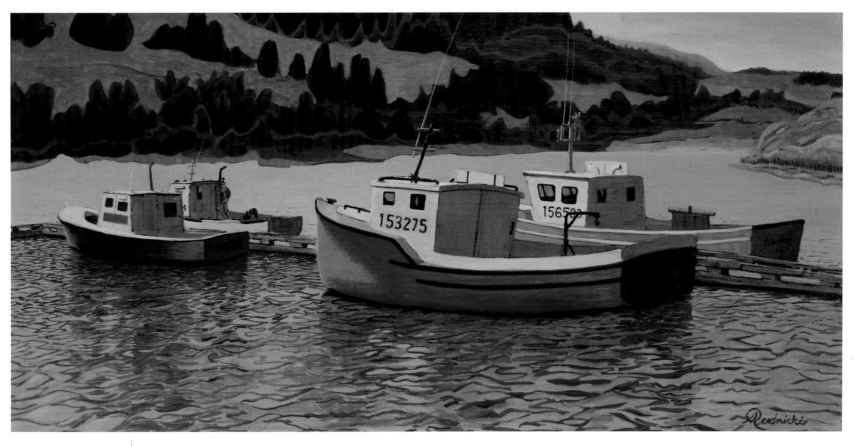

Cape Islanders, Dockside | acrylic on canvas–12″ x 24″

Robert Rutherford

Robert Rutherford has spent the past thirty years developing his distinctive style of Maritime images. His works are characterized by "a lot of wonderful curved movement, powerful, animated lines, and dramatic skies." (E. Barnard). He selects the best drawings to work into silk-screens in his studio. In September 2004 an exhibition of Rutherford's large acrylic landscape paintings titled Collective Experience was shown at the Houston North Gallery in Lunenburg, Nova Scotia. He has also participated in many group shows, including Hidden Values: Atlantic Corporations Collect and Art Expo '94, both at the Art Gallery of Nova Scotia and at Gallery Gabor in Toronto. His work was included in the Visual Arts Nova Scotia juried biennial exhibition, Far and Wide, in 1994 and 1996.

The Nova Scotia Department of Education produced an instructional film about the silk-screen process featuring Robert Rutherford and his work. He has produced two stop-motion films in which his art plays a major role.

SEVERAL TIMES A YEAR ROBERT RUTHERFORD LOADS HIS THIRTY-TWO-YEAR-OLD MOTORCYCLE WITH DRAWING AND CAMPING GEAR AND SETS OFF TO RE-ESTABLISH HIS CONNECTION WITH THE LIVING WORLD AROUND US. *He looks for windows opening into that world and to the ancient realities that never fade. When he finds such a porthole he sits himself down and draws or paints as the spirit moves him. No photographs! Later, working in his simple solar-heated studio, he selects the best of his impressions from which to create acrylic paintings or silk-screen images using the oldest and most truthful language of all—the language of symbols, to help others restore their connection to reality.*

—FARLEY MOWAT

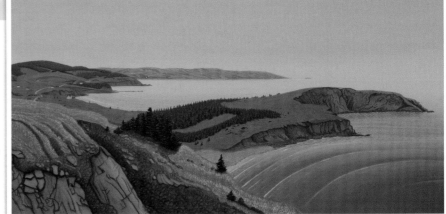

Broad Cove Marsh Point
acrylic
15" x 30"

(From the collection of
Pramod Jolly)

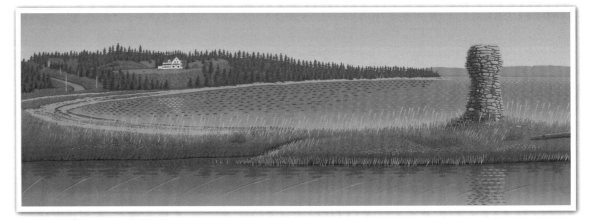

The Beacon | silkscreen–10" x 23"

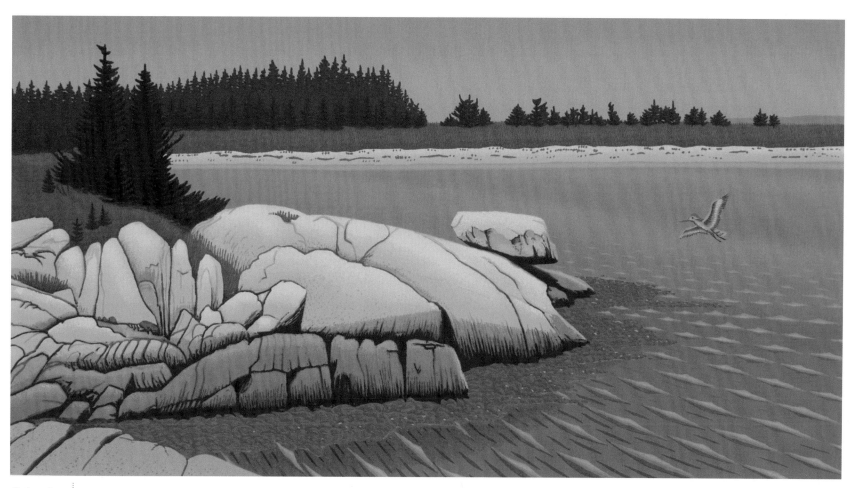

Shelter Cove | silkscreen–10" x 18"

Roger Savage

Roger Savage R.C.A. was born in Windsor, Ontario, grew up in Halifax, and graduated from Mount Allison University in 1963 with a degree in fine arts. He worked in printmaking, drawing, and watercolour through the 1970s and 1980s. The Royal Canadian Mint chose his designs for their 1976 and 1981 commemorative one-hundred-dollar gold coins. For the last twenty years Savage has devoted his practice to painting on site in many challenging locations: Ellesmere Island, Crete, Madeira, Colombia, Gotland, and Bermuda. An experienced resource artist, he has led many *plein air* workshops in the Maritimes, Bermuda, and Germany.

His work is included in many public collections, including the Art Gallery of Nova Scotia, Beaverbrook Art Gallery, Owens Art Gallery, Gotlands Kommun, and Glenbow Art Gallery. In 1985 Savage was honoured with election to the Royal Canadian Academy of Arts (R.C.A.). He has also served on the Art Gallery of Nova Scotia's board of directors. Since 1973, the artist has resided in Liverpool, the location of the Savage Gallery, which displays his work.

WATERCOLOUR HAS BEEN MY PRIMARY MEDIUM SINCE THE LATE 1980S. The constant challenge of working plein air, *the changing light, weather conditions, and the immediacy to the subject continue to inspire me. On site, I generally position myself facing the subject with the light behind it, so that the light and its reflections become an integral element in the composition. This rendering of the light contributes so much to the overall feeling of the painting. The spontaneity and fluid handling, combined with the strong highlights and shadows and the interplay of negative and positive components of the motif, are all vital in my work.*

Port Mouton Island, Nova Scotia 1981
watercolour
60 cm x 80 cm
© CARCC 2009

Rosehips, Summerville Beach, NS 1996 watercolour–17 cm x 22 cm © CARCC 2009

Sand Dunes, South Beach, Sable Island, NS 2005 watercolour–30 cm x 40 cm © CARCC 2009

Lynda Shalagan

Lynda Shalagan grew up on the Canadian West Coast in a damp climate with lush foliage. She began her formal art education at Capilano College in Vancouver, taking a craft program and studying ceramics, weaving, fabric design, and art history. After taking a class in painting, she felt she had found her medium. She transferred to the Nova Scotia College of Art and Design in Halifax to continue her studies and received a bachelor of fine arts in 1982. While teaching painting part-time and raising a son, she began her career as the art teacher at Sacred Heart School in Halifax. She began to devote herself more seriously to her own painting in the early 1990s when she began to exhibit and market her work on a more regular basis. At present, she works primarily in Halifax in a large studio (Artz Gallery) attached to her 1870s home with a large garden and pond.

I AM INTERESTED IN IMAGERY THAT OSCILLATES BETWEEN REPRESENTATION AND ABSTRACTION AND THAT REFERS TO CONNECTIONS BETWEEN FORMS AND THE STRUCTURES AND ENERGIES THAT CREATE THEM. The iconography in my paintings is based on plant forms, textures, and elements of the landscape. I am seeking to better understand the interaction of these elements and to look more deeply into these occurrences as a metaphor for human experience. I am very drawn to the materiality of my environment, and the fragile beauty exemplified in all stages of change. All stages made visible in the present from potential life to death are evident in the layers. In encouraging the paint to simulate the process of growth and decay through layering and surface texture, I hope to evoke the passage of time and continuous renewal.

Green River
oil on canvas
42" x 42"

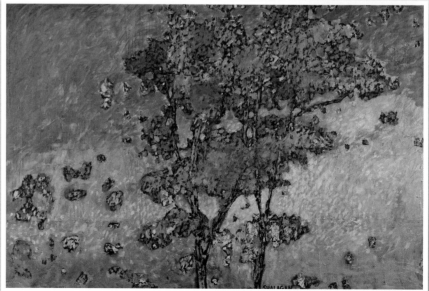

Red Tree | oil on canvas—40" x 60"

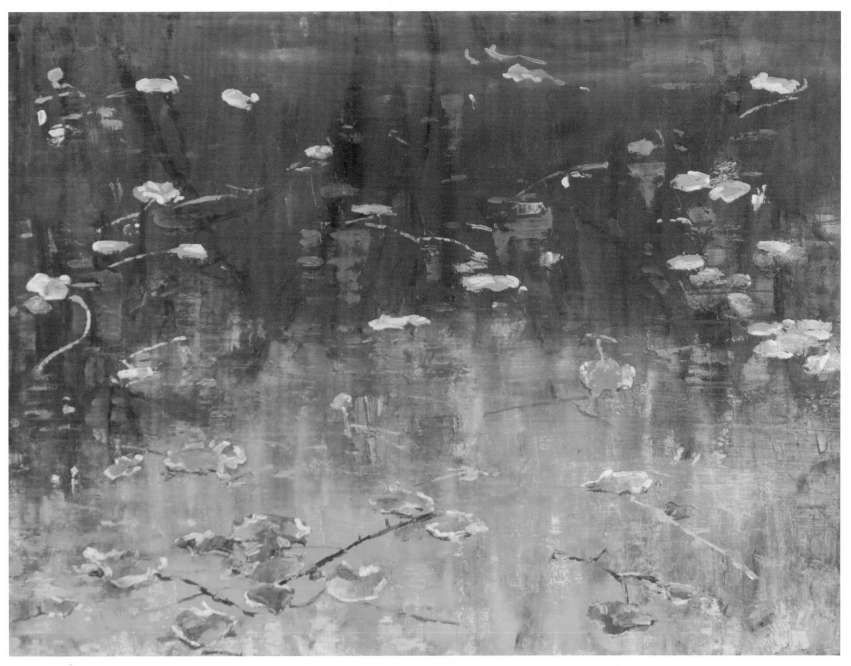

Yellow Pond | oil on canvas—45" x 60"

Johanna Steffen

Johanna Steffen received her academic and fine art training at the University of King's College, Halifax, where she received a bachelor's degree in classics and German, and at NSCAD, where she earned her bachelor of design in communication design and her bachelor of fine arts. Her work has been shown at the Moorings Gallery in Mahone Bay and Argyle Fine Art in Halifax.

MOST OF MY PAINTINGS ARE OF THE LAHAVE ISLANDS, A GROUP OF ISLANDS OFF THE SOUTH SHORE OF NOVA SCOTIA. *In these paintings, I try to reduce the landscape to its basic forms, using minimal brush strokes. Sometimes the foreground becomes almost abstract. I use colour to create depth and to capture the character of the landscape; for example, by using muted colours to suggest fog or overcast skies.*

LaHave Island Trees #3
oil
8″ x 8″

Rocks #3 acrylic–11″ x 14″

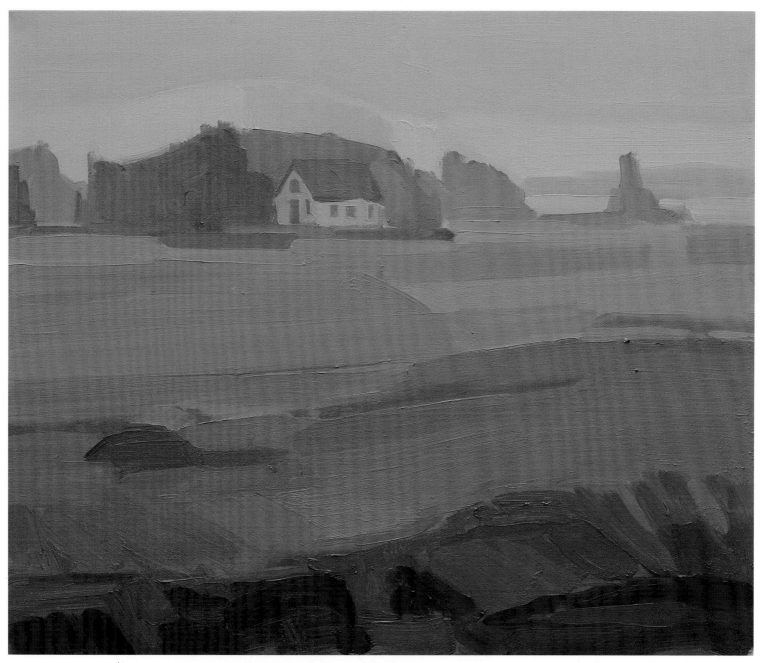

View from Bush Island : oil–20" x 24"

Gail Sutherland

Gail Sutherland is originally from Montreal and has been residing in Nova Scotia for more than eighteen years. She studied fine arts at John Abbott College, then completed her bachelor of fine arts at Concordia University, specializing in graphic design. She has attended workshops with Québec artists and studied at the Saidye Bronfman Centre, and McGill and NSCAD universities. Her work has been shown at the Raven Gallery in Tatamagouche, Lyghtesome Art Gallery in Antigonish, and Dune Gallery in Brackley Beach, Prince Edward Island. Gail and her family reside in Bedford, where she works as an artist and graphic designer.

To SIMPLIFY, TO FOCUS,
to balance the seen, with the unseen,
to capture the spirit, heart and soul…
the painting's reason for being.

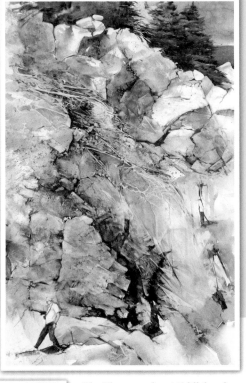

The Photographer, Middlehead,
Cape Breton Island, N.S.
watercolour
20" x 13"

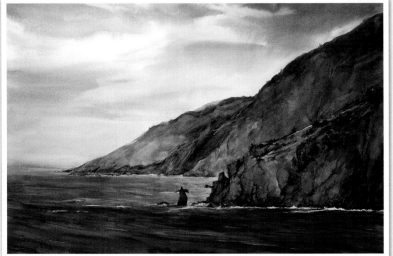

Stone Angel, Pollets Cove, Cape Breton Island, N.S. watercolour–16.5" x 25.5"

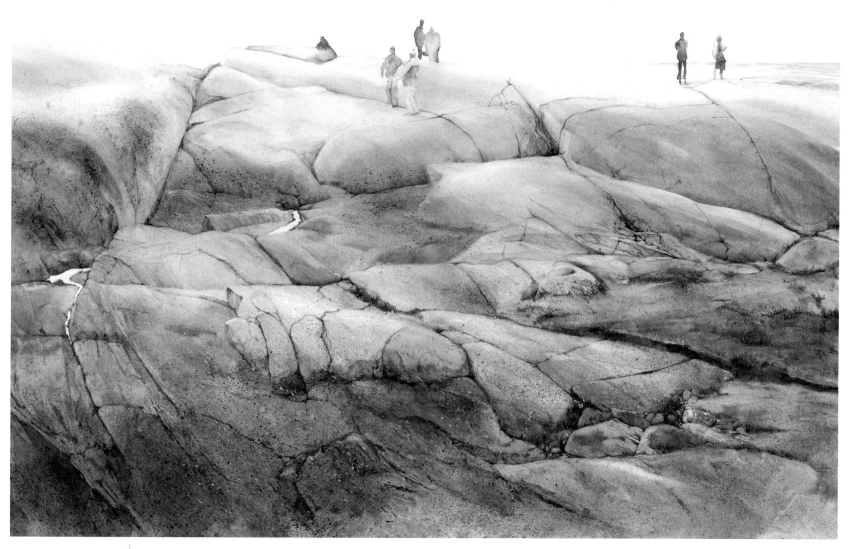

Seven, Peggy's Cove, N.S. watercolour–13.5" x 21"

Alan Syliboy

Alan Syliboy was born in Truro in 1952 and raised in Millbrook First Nation, a reserve which is part of Truro, where he still resides. In 1971 he studied privately with Maliseet artist Shirley Bear, of Tobique, New Brunswick. They both started discovering petroglyphs, which continue to have a strong influence on Syliboy's work. In 1975 he attended NSCAD and twenty-five years later, he was appointed to its board of governors.

In 1999 Syliboy was commissioned to design the two-hundred-dollar, twenty-two-karat gold coin for the Royal Canadian Mint. He was presented the Queen's Golden Jubilee Medal in 2002. In 2007 he illustrated The Stone Canoe, known to be the oldest Mi'kmaq literature in North America. Syliboy curated an exhibit called Ekpahak, for the Lord Beaverbrook Art Gallery, in Fredericton, New Brunswick, in 2009. He has been a three-time juror for the Canada Council, and a juror for the Aboriginal Achievement Awards and the New Brunswick and Nova Scotia Arts Councils. He is working on an animation piece for the 2010 Olympics with photographer Nancy Ackerman and the National Film Board, and submitting work that will be a part of the Olympics.

I GREW UP BELIEVING THAT NATIVE ART WAS GENERIC—WHAT YOU SEE ON TV AND IN OTHER MASS MEDIA. Visual expressions are part of what makes a culture unique, and although Mi'kmaq designs are similar to other North American woodland tribes, you can easily recognize the differences. I looked to the indigenous Mi'kmaq petroglyph tradition for inspiration and developed my own artistic vocabulary out of those forms. This purely Mi'kmaq vocabulary has allowed my brush and pen to lead me to images of family for my series of serigraph prints, and more recently for my memory portraits of my relatives that I call The Syliboy Series. I celebrate past, present, and future of strong family ties in a series of spritely images that suggest the fantasies of Klee and Miro, but their artistic roots are firmly entwined around the rocks found in the ancient grounds of Nova Scotia.

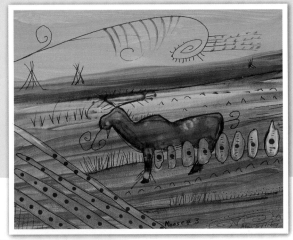

Moose #3
acrylic and pen on
paper
10" x 20"

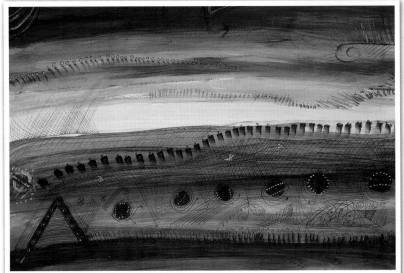

Sunset | acrylic and pen on paper—20" x 30"

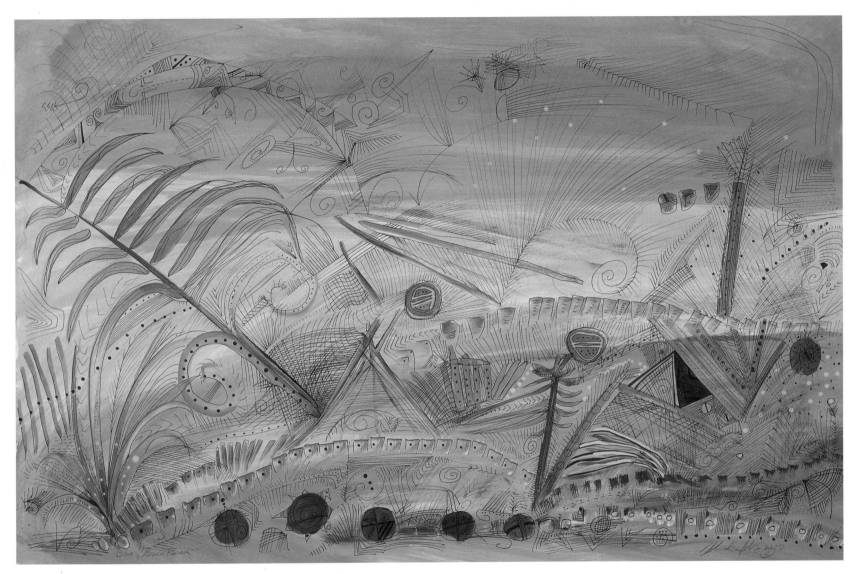

Untitled | acrylic and pen on paper–20″ x 30″

Anna Syperek

Anna Syperek was born in England in 1950, grew up in Ontario, and moved to Antigonish, Nova Scotia, in 1971. She graduated from the Nova Scotia College of Art and Design in 1980. She paints in oil and watercolour (most often outdoors or in the car), makes etchings, and teaches advanced drawing part-time at St. Francis Xavier University. She has had numerous solo shows in public galleries in the Maritimes and Ontario, and in 2005, her exhibition Old New Scotland travelled from Nova Scotia to four venues in Scotland, courtesy of the Highland Council of Scotland.

"There are places, just as there are people, and objects and works of art, whose relationship of parts creates a mystery, an enchantment, which cannot be analyzed. This place of mine was not remarkable for any unusual features which stood out. Yet there was a particular spacing in the disposal of the trees, or it was their height in relationship to these intervals, which suggested some inner design of very subtle purpose."

Paul Nash, British artist, 1889–1946

Nash's quote expresses the pull that I have felt since I was a child to certain landscapes and what draws me to my subject matter. My work is also tempered by my admiration for certain artists, my cultural background, my teachers, and my disposition. I like to paint on location as much as possible, so the work is also influenced by the heat of the sun, the changing light, the bugs, the wind; many subtle changes occur both in what I am painting and in the way I see it over the time I sit there taking it in.

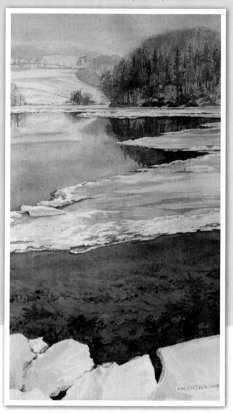

Winter Water—The Harbour
watercolour
22" x 12"

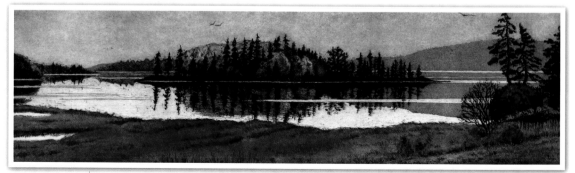

Harbour Centre | two-plate etching and aquatint–5" x 18"

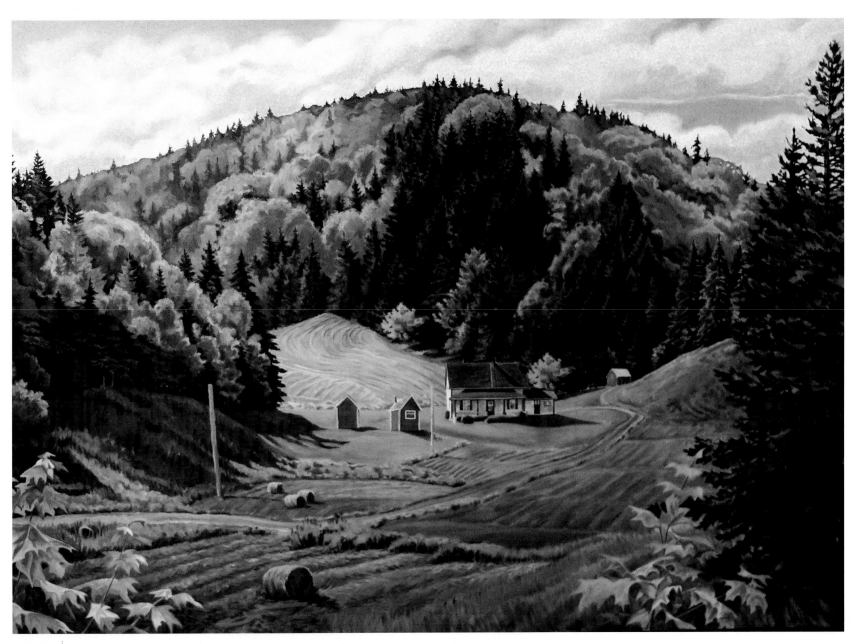

Gillisdale | oil–28″ x 42″

Born in the farmlands of New Jersey, Susan Tooke was interested in art from an early age, spending time drawing the natural world around her. She studied art at Virginia Commonwealth University where she earned her bachelor of fine arts. Upon graduation, she taught art in Newark, New Jersey, while doing graduate work in media studies at the New School in New York City. A dual citizen, Tooke moved to Canada in 1980, and has been working as a full-time artist since then. Her studio work reflects her interest in landscape painting based on travels to such far-flung places as Alaska, the American South and Southwest, Newfoundland and Labrador, and Sable Island.

Over the past ten years, much of her focus has been directed toward illustrating children's picture books, with eight published to date, winning numerous awards. These include *Up Home* by Shauntay Grant, *A Fiddle for Angus* by Budge Wilson, *Full Moon Rising* by Joanne Taylor, *Free As the Wind* by Jamie Bastedo, and *B is for Bluenose*, which she both wrote and illustrated. Intrigued by a number of other media, Tooke continues exploration and collaboration in digital montage, dioramas, murals, and multimedia.

My love for the land grows from a childhood exploring the fields, farms, and woods of the East Coast. My paintings, illustrations, and museum pieces contain landscapes from all over the Maritimes. In Nova Scotia I feel connected; spiritually grounded to the land and tied to the sweep of time and the history of its people. Composition and colour are as critical to my work as context. I find myself drawn to images of the human element within the landscape. This can be as subtle as a vapour trail in the sky, or as palpable as the artificial landscape of the Halifax Public Gardens. Land in context is land in relationship, revealing a dynamic tension between nature and humanity. Combining content and context, I mix people, places, and things to provoke a blend of mystery, time, and place. As a painter, I consider growth and exploration into new approaches to art-making critical in keeping work fresh. I am at work on a series of paintings inspired by my interest in the public gardens and the human figure, with a simplification of form, an exaggeration of colour saturation, and complementary underpainting.

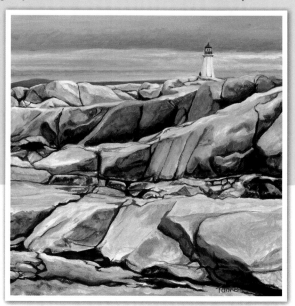

Rocks and Light
acrylic
8" x 8"

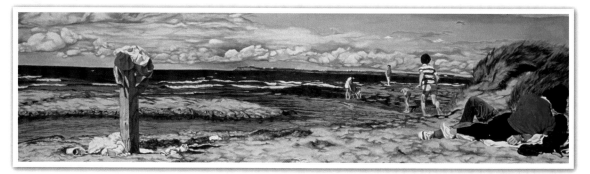

East of Brule | acrylic–21" x 72"

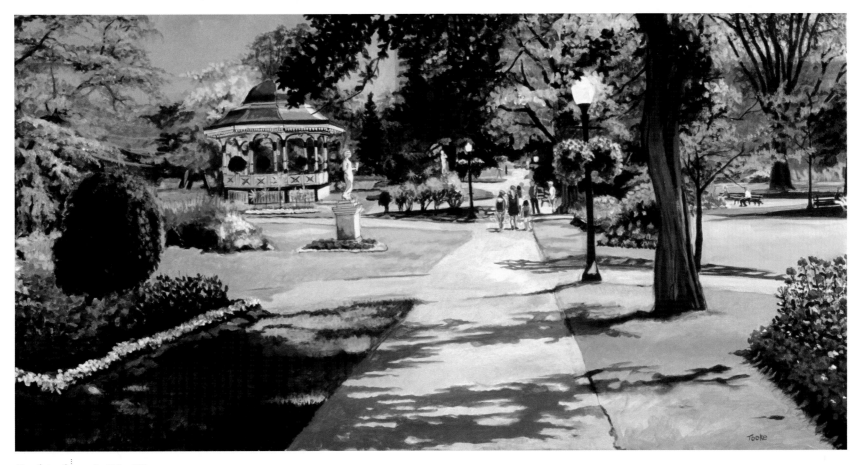

Bandstand | acrylic–18" x 36"

Chris Wallace

Born in Dundee, Scotland, in 1962, Chris Wallace immigrated to Nova Scotia in 1967. He returned to Scotland in 1980 for his post-secondary studies, but returned to Canada in 1994 and now resides in Nova Scotia. Wallace obtained his Ordinary National Diploma in Graphic Arts, from the College of Commerce in Dundee. He then attended Duncan of Jordanstone College of Art and Design, receiving his bachelor of arts with honours in 1989, and a post-graduate diploma of fine arts in 1990. He is the recipient of the James Guthrie Orchar Memorial Award for landscape painting, and twice the recipient of the Elizabeth Greenshields Award, in 1989 and 1991.

THROUGH MY WORK I WISH TO DECLARE THE VALUE AND SIGNIFICANCE OF THE OBJECTIVE WORLD. *By focusing on the substance, light, and relationship of the subjects in my paintings, I hope to transcend their everyday existence and create symbols of a spiritual and poetic vision. My two primary media are egg tempera and watercolour. Tempera is a very slow and plodding medium. The design has to be well worked out in advance, and the application of the raw, dried pigments mixed with egg yolk and water has to be done in a multitude of thin, semi-opaque layers. Tempera cannot be blended on the surface. Every gradation of tone must be mixed on the palette as a separate colour and applied using a small brush with either small strokes or dots. The effect, however, has a luminous, shimmering quality that no other medium possesses. Watercolour gives me the opportunity to be more spontaneous with my brushwork, as well as providing the discipline of being decisive and bold.*

Porters Lake
egg tempera on gessoed panel
22" x 24"

Lawrencetown Lake watercolour on paper–21" x 28"

Martinique | egg tempera on paper–22" x 36"

Tom Ward

Born in Halifax in 1959, Tom Ward studied geology at Dalhousie University and worked for four years in the university's Oceanography Department. From 1986 to 1991, he pursued a combined degree in fine arts and art education at the Nova Scotia College of Art and Design. He worked for a year as a teacher. Since 1993, Ward has worked full-time as a painter in watercolour.

To a large degree, my painting reflects my experience; in a formal sense the tradition of American and Canadian east coast realists such as Hopper, Wyeth, Homer, and Christopher and Mary Pratt have influenced my aesthetic. My goal is to paint the light and what that particular light evokes in fact and mood. I am drawn to a consideration of how we mark time in the rhythms of daily rural life, and how the cyclical aspect of nature holds a quality of the eternal. I am also drawn by the relationship that exists between the landscape, the ocean, and the people. In terms of composition, I tend towards strong abstract patterns of light and shadow within the realist images I paint. The essential qualities of the watercolour medium are its lightness and immediacy, yet I work in a way that aims to balance strong, saturated mixtures of colour with translucency and carefully controlled washes with spontaneity. This method allows me to work a surface toward greater detail and achieve the realist ends I seek.

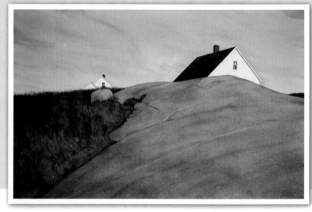

Houses at Peggy's Cove
watercolour
15" x 23.5"

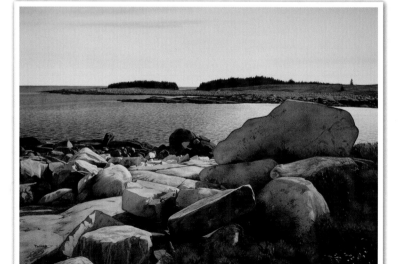

Kejimkujik Seaside Adjunct watercolour–15.75" x 23.5"

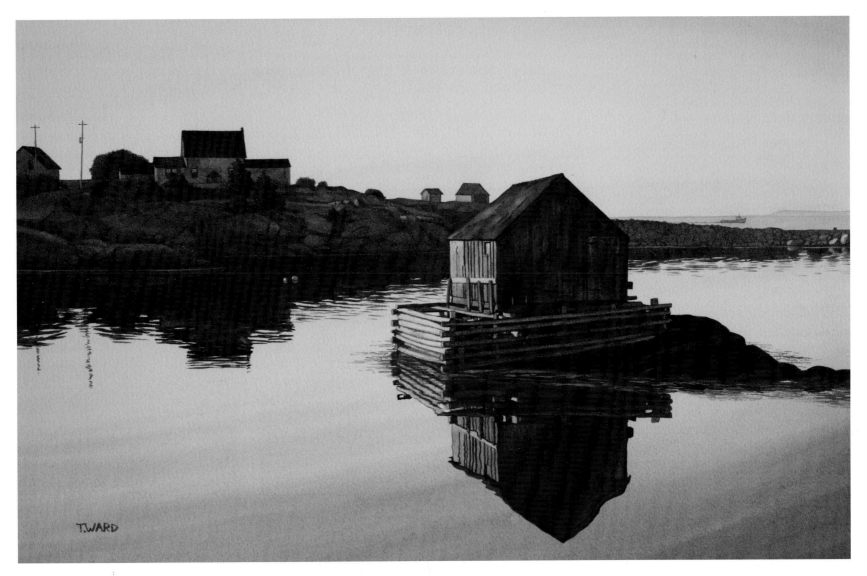

Sunrise, Blue Rocks | watercolour–13" x 17.75"

Marilyn Whalen

Born in Corner Brook on the west coast of Newfoundland, Marilyn Whalen developed a deep appreciation for the beauty of the mountains, rivers, and forests of the province. She began her artistic journey first in photography, then in watercolour, and now joyously paints in a variety of styles, from impressionistic to abstract, in oil and acrylic. Marilyn is a self-taught artist and a member of the Truro Art Society.

Whalen's work can be found in private and corporate collections across Canada. She lives in Truro and teaches painting at her studios in Truro and Halifax.

PAINTING HAS BECOME A WAY IN WHICH I EXPRESS MY FASCINATION WITH THE EVER-CHANGING LIGHT AND SEASONS HERE IN THE MARITIMES. *While some of my work can be representational, I am equally committed to capturing its emotional, subjective side. I want my passion for what I see and feel to come through and provoke the same kind of enthusiastic response in the viewer.*

Much of my current work focuses on landscapes and florals in larger formats. Splashes of reds and blues appear in nearly every one of my paintings. I use multiple layers of colour and a variety of textures, often scraping through them with various tools to show line, energetic movement, and dynamic colour variations. My goal is for you, the viewer, to be excited and inspired by a subject that has inspired me.

Wentworth Walk
acrylic on canvas
36" x 24"

Sunrise at Victoria Park acrylic on canvas–36" x 36"

Fall's Glory | acrylic on canvas–24" x 36"

Carol Whitcombe

Carol Whitcombe was born and raised in Winnipeg, Manitoba. She enjoyed an extensive career in the commercial/graphic arts field for thirty-two years. An elected member of the Canadian Society of Painters in Water Colour, she has had her work displayed in galleries in Winnipeg, Toronto, Halifax, Lunenburg, Cuba, and the southwestern United States, and has won many awards for her highly realistic watercolours. Her work can be found in private collections throughout North American, Great Britain, Japan, and Europe. At present, Carol showcases her work primarily in her home-based Spirit Song Gallery in Mahone Bay.

I BEGAN PAINTING AT THE TENDER AGE OF TWELVE, WHEN I PICKED UP A BRUSH AND EXPERIENCED THE LUSCIOUS COLOURS AND TEXTURES OF MY FIRST SET OF OILS. I transitioned through the medium of acrylics and then, in my late thirties, discovered the excitement and challenges of depicting realism with transparent watercolours. Since then, each painting becomes a new challenge as I embark on a journey, exploring the feelings my chosen subject evokes within me. I find the rugged Maritime landscapes a constant source of inspiration, and hope to stimulate the viewer into experiencing the enjoyment and awareness of the intimate moments with nature and the world around us that inspire me to create a painting. While representing the beauty I see in a truly realistic manner, through intensity of colour and composition, I endeavour to infuse each subject with a life and depth beyond mere reproduction.

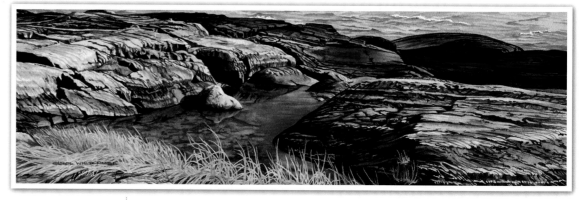

Tidal Pool at Blue Rocks watercolour–7.75" x 25"

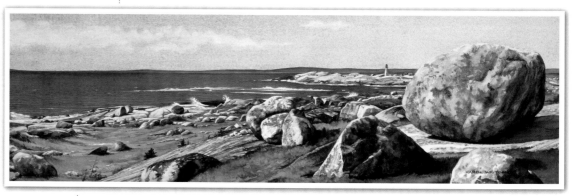

The Guardians watercolour–7.5" x 25"

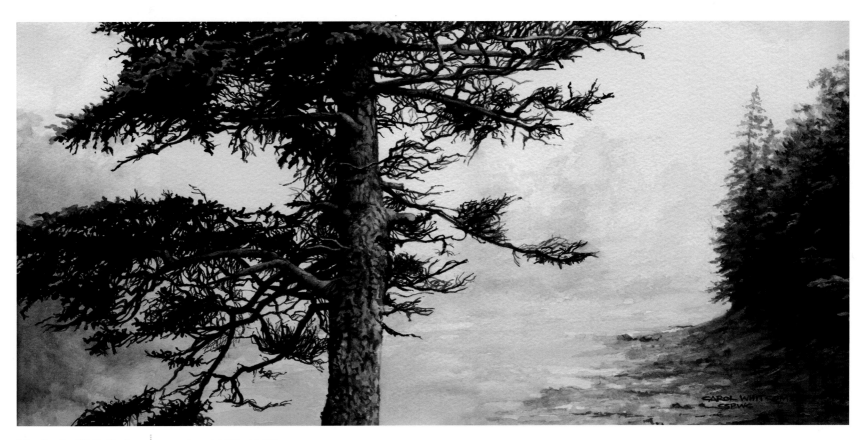

Matriarch of Halls Harbour | watercolour—18.75″ x 10.28″

Charlotte Wilson-Hammond

Charlotte Wilson-Hammond is a visual artist living and working on Nova Scotia's Eastern Shore. For the past thirty years Charlotte has been an active advocate for the arts, both provincially and nationally. She was a founding member of Visual Arts Nova Scotia, Eyelevel Gallery, and the Coalition for Arts and Culture. She has also served on the board of governors of the Nova Scotia College of Art and Design, the Art Gallery of Nova Scotia, the Canadian Conference of the Arts, and Canadian Artists' Representation.

In 2002 Wilson-Hammond was featured in a major retrospective exhibition, Landscape with Thighs, curated by Peter Dykhuis at the Art Gallery of Nova Scotia. In 2004 she was awarded the Portia White Prize, a twenty-five-thousand-dollar award honouring a senior artist in the province of Nova Scotia. She used part of the award to establish the Charlotte Wilson-Hammond Visual Arts Nova Scotia Scholarship, administered through the Nova Scotia Talent Trust to an exceptional visual arts student. Wilson-Hammond exhibited new work titled In/Finite at the Inverness Centre for the Arts in 2005, and at Arts/Place in Annapolis Royal in 2006. She was elected to the Royal Canadian Academy of the Arts in the spring of 2006.

My work explores images and associations with the land, earth, and sea, as well as the human form, using mixed media to convey the depth of sensuality and fragility of the world.

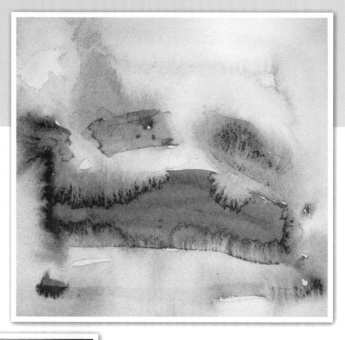

Infinite #7
giclée with coloured pencil on photo rag paper
48" x 48"

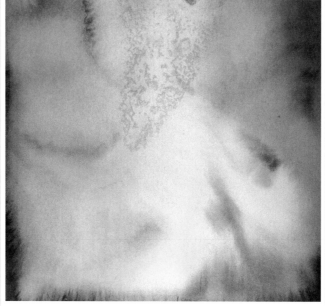

Infinite #2 giclée with coloured pencil on photo rag paper–48" x 48"

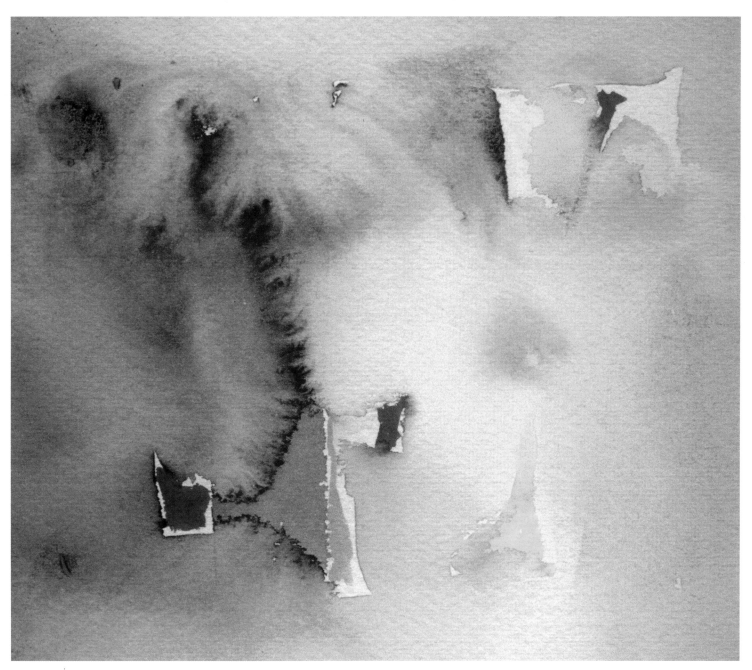

Infinite #3 | giclée with coloured pencil on photo rag paper—48" x 48"

Bruce John Wood

Bruce John Wood is a full-time painter, sculptor, and illustrator. In the past decade he has produced ten limited edition prints, four historical murals, numerous book illustrations and magazine covers, and several posters for the Department of Natural Resources. He has many one-man shows to his credit, as well as works commissioned by Environment Canada. In 1992 Wood designed the Nova Scotia coin for the Royal Canadian Mint under the Canada 125 initiative. Most recently his time has been spent in depicting the Atlantic salmon (an endangered resource) sport fishery by travelling to various locations each spring and summer to sketch and photograph river locales. Wood lives in Truro.

THE CRUCIAL TEN THOUSAND HOURS THAT ONE MUST PUT IN BEFORE PUBERTY, TO ASSURE THAT ONE IS A LEADER IN THE FIELD OF CHOICE, OR AT LEAST COMPETENT, HAVE BEEN DONE HONESTLY, AND DONE BEFORE I KNEW THIS CRITERIA WAS AN UNWRITTEN RULE! I'm not sure where the fascination for drawing had sprung from to completely control my life all these many years, but it is inescapable in myself. Michelangelo stated that sculpture and painting ruined his life! I believe that he was speaking of the stranglehold that art had on him, leaving no room for him to have a normal life. I can certainly understand this!

From early days I have been drawn to representational art and the highly detailed works of well-known illustrators such as Arthur Rackham, Norman Rockwell, and N. C. Wyeth. Lately I've been appreciating the Impressionists more, from Monet to our own Group of Seven. Their loose and painterly style has taken on a real appeal for me and has sent me in a fresh new direction.

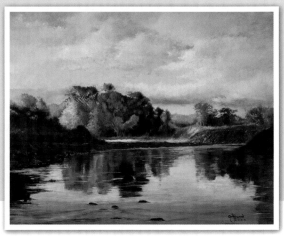

October on the West River
oil on canvas
16" x 20"

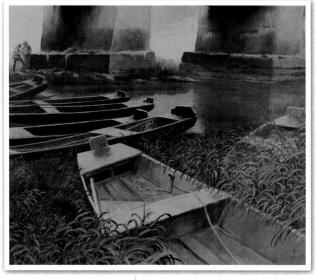

Salmon Boats at Silvers Pool | acrylic on canvas—22" x 28"

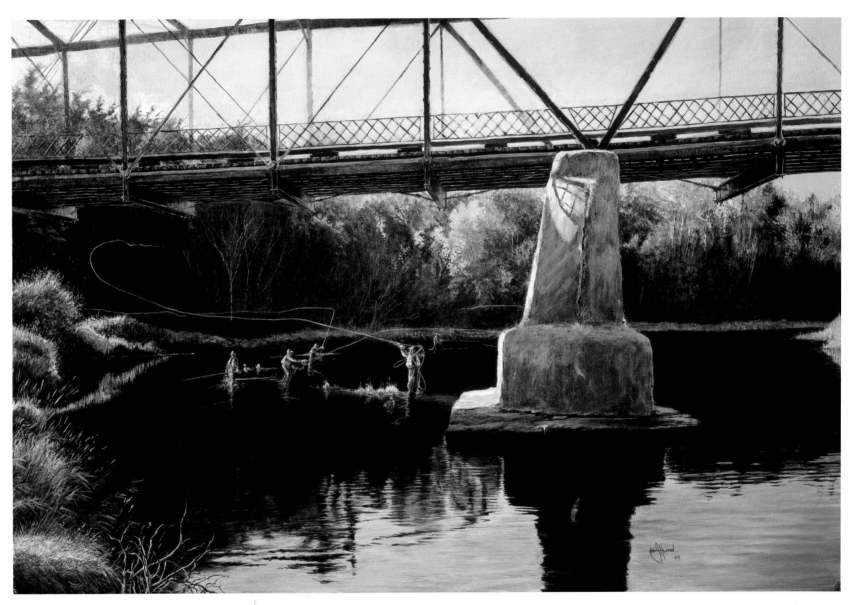

The Fly Casters Ballet (Kerrs Bridge, Wallace River) | oil on canvas–24" x 30"

Fine Art Galleries in Nova Scotia

Evangeline Trail

Acadia University Art Gallery
Beveridge Arts Centre,
Wolfville
Tel: (902) 585-1373
artgallery@acadiau.ca
www.gallery.acadiau.ca

Apple Pie Pottery and Gallery
Margaret Jansen
106 Main St., Middleton
Tel: (902) 825-4935
applepiepottery@eastlink.ca

Art Can Gallery and Café
Ron Hayes
9850 Main St., Canning
Tel: (902) 582-7071
ron@artcan.com
www.artcan.com

ARTsPLACE Gallery
Annapolis Region Community
Arts Council
396 St. George St., Annapolis Royal
Tel: (902) 532-7069
arcac@ns.aliantzinc.ca
www.arcac.ca

Bateman/Carr Studio & Gallery
299 Woodside Rd, RR #5, Canning
Tel: (902) 582-3309
mail@alanbateman.com
http://www.alanbateman.com

Castle Art Gallery
Herb Anderson
Stone House at Upper Clements Park,
Annapolis Royal
Tel: (888) 248-4567
fun@upperclementspark.com
www.upperclementspark.com

Charles Couper Studio
735 Riverview Rd.
RR #1, Bear River
Tel: (902) 467-3162

David Lacey Gallery
4092 Route 359, RR #3, Hall's Harbour,
Centreville
Tel: (902) 679-7073
davidlaceygallery@canada.com
www.davidlaceygallery.com

Evergreen Studio
Linda Barkhouse
1026 Evergreen Ave., New Minas
Tel: (902) 681-2895
v.l.barkhouse@ns.sympatico.ca
www.geocities.com/paintsandpots/
Lindabarkhouse.html

Freda Nauss Studio
2753 Mountain View Rd., Coldbrook
Tel: (902) 679-3474
fredabud@ns.sympatico.ca
www.geocities.com/paintsandpots/
FredaNauss.html

Geoff Butler Art Studio
5318 Granville Road, Granville Ferry
Tel: (902) 532-5707
geoffbutler@ns.sympatico.ca
www3.ns.sympatico.ca/geoffbutler/

Harvest Gallery
Lynda Macdonald
462 Main St., Wolfville
Tel: (902) 542-7093
lyndamac@harvestgallery.ca
www.harvestgallery.ca

Japanese Art & Antiques
Gallery
Tom Haynes-Paton
8121 Hwy 101, Barton
Tel: (902) 245-2347
japanesegallery@gmail.com
www.japanesewoodblockprints.ca

June Deveau Galerie Studio
7236 Route 1, St. Alphonse
RR #1, Meteghan
Tel: (902) 645-3106
june@junedeveau.com
www.junedeveau.com

King's Theatre Art Gallery
Mary Lynn McWade
88 Pickup Rd., RR #2, Annapolis Royal
Tel: (902) 638-3247

La Galerie Comeau
761 Route 1, Comeauville
Tel: (902) 769-2896
info@lagaleriecomeau.com
www.lagaleriecomeau.com

Maher Art Gallery
2554 Hwy 201, RR #3, Bridgetown
Tel: (902) 665-2426
elizabeth.rice@cbdc.ca
www.mahergallery.com

Marsh Gallery
3994 Hwy 1, Annapolis Royal
Tel: (902) 532-7773
janet@studiolark.ca
www.marshgallery.ca

Oriel Fine Art
Judith Leidl
11 Bay St., Wolfville
Tel: (902) 542-2772
orielfineart@ns.sympatico.ca
www.judithleidl.com

Ross Creek Centre for the Arts
555 Ross Creek Rd., Canning
Tel: (902) 582-3842
mail@artscentre.ca
www.artscentre.ca

Fine Art Galleries in Nova Scotia

Studio Lark
RR #1, Bridgetown
Tel: (902) 532-1882
janet@studiolark.ca
www.studiolark.ca

**The Printmaker
Studio & Gallery
Bob & Judy Hainstock**
1688 Brow of Mountain Rd., RR #3,
Centreville
Tel : (902) 582-3656
bob@theprintmaker.ca
www.theprintmaker.ca

Utata Gallery and Art Centre
40 Water St., Windsor
Tel: (902) 792-2710
www.gallery.utata.org

Windsong Studio & Gallery
1331 Victoria Rd., Aylesford
Tel/Fax: (902) 847-9847
windsong1331@yahoo.ca
www.windsong-nature-gallery.com

Glooscap Trail

Joy Laking Gallery
6730 Hwy 2, Portapique
Tel: (800) 565-5899
joy@joylakinggallery.com
www.joylakinggallery.com

Destination Gallery
219 Main St., Parrsboro
Tel: (902) 254-2658
rmccaffrey@seaside.ns.ca
www.thedestinationgallery.com

Northumberland Region

Alice Reed Studio Gallery
Pomquet
Tel: (902) 386-2501
bancroftreed@auracom.com
By appointment only

**Down To Earth
Art Gallery Inc.**
240 Main St., Antigonish
Tel: (902) 863-3255
orders@downtoearth.ca
www.downtoearth.ca

Horton House Gallery
10162 Durham St., Pugwash
Tel: (902) 243-3210
fhorton@ns.sympatico.ca
www.fredhortonphotography.com

**Lyghtesome Gallery
Jeffrey and Elizabeth Parker**
166 Main St., Antigonish
Tel (gallery): (902) 863-5804
 (800) 303-6546
Tel (workshop): (902) 863-8122
lyghtesome@eastlink.ca
www.lyghtesome.ns.ca

**Raven Gallery
and Frame Shop
Sharon McKenna**
267 Main St., Tatamagouche
Tel: (902) 657-0350
sharon_ravengallery@yahoo.ca

**St. Francis Xavier University
Art Gallery**
Bloomfield Centre, Antigonish
Tel: (902) 867-2303

William Rogers Studio
4 Carter Cres., Antigonish
billrogers@eastlink.ca
www.gapacc.ns.ca/williamrogers

Truro and area

**Marigold Cultural
Centre Gallery**
605 Prince St., Truro
Tel: (902) 897-4004
www.marigoldcentre.ca

Truro Arts Society
McCarthy Hall Gallery
Nova Scotia Community College
36 Arthur St., Truro
www.truroartsociety.wordpress.com

**Red Crane Studios
Alan Syliboy**
184 Arthur St., Suite 227, Truro
Tel: (902) 956-0085
alan@redcrane.ca
www.redcrane.ca

Robb Scott
2221 Lilyvale Road, Greenfield
artist@robbscottdrawings.com
www.robbscottdrawings.com

**Thrown Together
Pottery & Art
Danielle Sawada**
37 King St., Truro
Tel: (902) 895-9309
throwntogether@ns.sympatico.ca
www.throwntogetherpottery.com

Gallery 215
8247 Hwy 215, Selma, Hants County
Tel: (902) 261-2151
artgallery215@hotmail.com
www.artgallery215.com

Ceilidh Trail

**Doug Fraser Art
Studio and Gallery**
178 Loch Ban Rd., RR #1, Inverness
Tel: (902) 258-2455
dougfraserart@ns.sympatico.ca
www.dougfraserart.com

**Inverness County
Centre for the Arts**
16080 Hwy 19, Inverness
Tel: (902) 258-2533
www.invernessarts.ca

**Mabou Village
Gallery & Guesthouse
Suzanne Chrysler MacDonald**
11582 Main St., Mabou
Tel: (902) 945-2060
s.chryslermacd@ns.sympatico.ca

**Gallery Ruairicroft
Berni Thorneycroft**
RR #2, Civic #3170, West Bay
Tel: 902-345-0707
haggis@auracom.com

Fleur-de-Lis Trail/ Metro Cape Breton

**Cape Breton University
Art Gallery**
1250 Grand Lake Rd., Sydney
Tel: (902) 563-1342
art_gallery@cbu.ca
www.capebretonu.ca/artgallery

**Kenny Boone Gallery &
Studio**
230 Neville St., Dominion
Tel: (902) 849-5820
art@kennyboone.ca
www.kennyboone.ca

Cabot Trail

**Cranberry Patch
Fine Arts & Gifts
Paula Courtney**
27742 Cabot Trail, Big Intervale
Tel: (902) 383-2337
paula.courtney@ns.sympatico.ca
www.cranberrypatcharts.com

**Lynn's Craft Shop
and Art Gallery**
36084 Cabot Trail, Ingonish
Tel: (902) 285-2735
lynnsgallery@ns.sympatico.ca
www.goreygallery.ca

**The Water's Edge Inn,
Café & Gallery
Anne and Jeff Ertel**
18 Water St., Baddeck
Tel: (902) 295-3600
thewatersedge@baddeck.com
www.thewatersedgegallery.com

Arts North
Cabot Trail, Cape North
Tel: (902) 383-2911 or (902) 383-2732
office@arts-north.com
www.arts-north.com

Sunset Art Gallery
15856 Cabot Trail, Chéticamp
Tel: (902) 224-2119 or (902) 224-1831
info@sunsetartgallery.ca
www.sunsetartgallery.ca

Marine Drive

Harris & Company Art Gallery
1104 West Jeddore Rd., Head Jeddore
Tel: (902) 430-2135
randy@harrisandcogallery.ca
www.harrisandcogallery.ca

**Black Sheep Gallery
Audrey Sandford**
1689 West Jeddore Rd., West Jeddore
Village
Tel: (902) 889-5012
blacksheep@eastlink.ca
www.blacksheepart.com

Fisherman's Cove Gallery
10 Government Wharf, Fisherman's
Cove, Eastern Passage
Tel: (902) 461-4099

Halifax Metro

**Anna Leonowens Gallery
Nova Scotia College of Art
and Design**
1891 Granville St., Halifax
www.nscad.ns.ca

Argyle Fine Art
1869 Upper Water Street, Halifax
Tel: (902) 425-9456
gallery@argylefa.com
www.argylefa.com

art & jules
2089 Gottingen Street, Halifax
Tel: (902) 448-8420
artandjules@gmail.com
www.artandjules.com

The Gallery at FRED
2606 Agricola Street, Halifax
Tel: (902) 423-5400
info@fredsalon.ca
www.fredsalon.ca

Fine Art Galleries in Nova Scotia

Art Gallery of Nova Scotia
1723 Hollis St., Halifax
Tel: (902) 424-7542
info@gov.ns.ca
www.agns.gov.ns.ca

Art Sales and Rental Gallery
Art Gallery of Nova Scotia
1723 Hollis St., Halifax
Tel: (902) 424-3087
www.agns.gov.ns.ca

Corridor Gallery
Visual Arts Nova Scotia
1113 Marginal Rd., Halifax
www.vans.ednet.ns.ca

Craig Gallery at
Alderney Landing
Kim Farmer
2 Ochterloney St., Dartmouth
Tel: (902) 461-4698
info@alderneylanding.com
www.alderneylanding.com

Dalhousie Art Gallery
6101 University Ave., Halifax
Tel: (902) 494-2403
gallery@dac.cohn.dal.ca

Eyelevel Gallery
2063 Gottingen Street, Halifax
Tel: (902) 425-6412
director@eyelevelgallery.ca

Gallery Page and Strange
1869 Granville St., Halifax
Tel: (902) 422-8995
info@pageandstrange.com
www.pageandstrage.com

Hydrostone Gallery
Hydrostone Market
5519 Young St., Halifax
Tel: (902) 444-3050
info@hydrostonegallery.com

Forrestall Fine Arts Ltd.
3 Albert St., Dartmouth
Tel: (902) 469-7454

Khyber Centre for the Arts
1588 Barrington St., Halifax
Tel: (902) 422-9668
www.khyberarts.ns.ca

Art 1274 Hollis
1274 Hollis Street, Halifax
Tel: (902) 446-4077

www.art1274hollis.com

Maritime Fine Art Studios
Barrington Place Shops
1903 Barrington St., Halifax
Tel: (902) 422-9606

Mount Saint Vincent
Art Gallery
Seton Academic Centre
166 Bedford Highway, Halifax
Tel: (902) 457-6160
www.msvuart.ca

Painter's Palette Gallery
Spring Garden Place
5640 Spring Garden Road, Halifax
Tel: (902) 435-4619
painterspg@yahoo.ca

Red Door Art Gallery
1480 Fall River Rd.,Waverley
Tel: (902) 860-0274

Saint Mary's
University Gallery
Loyola Academic Complex,
first floor
5865 Gorsebrook Avenue, Halifax
Tel: (902) 420-5445
www.smuartgallery.ca

Secord Gallery
6301 Quinpool Rd., Halifax
Tel: (902) 423-6644
info@secordgallery.com
www.secordgallery.com

Seeds Gallery, NSCAD
University
1892 Hollis St., Halifax
www.nscad.ns.ca/seedsgallery

Studio 21 Fine Art
Ineke Graham
1223 Lower Water St., Halifax
Tel: (902) 420-1852
fineart@studio21.ca
www.studio21.ca

The Gallery @
Creative Crossing
5781 Charles St., Halifax
www.creativecrossing.ca

ViewPoint Gallery
1272 Barrington St., Halifax
Tel: (902) 420-0854
info@viewpointgallery.ca
www.viewpointgallery.ca

Zwicker's Gallery
5415 Doyle St., Halifax
Tel: (902) 423-7662
service@zwickersgallery.ca
www.zwickersgallery.ca

Lighthouse Route

ADJA Studio and Gallery
177 Main Street, Liverpool
Tel: (902) 354-4167
adja@eastlink.ca
www.adjastudioandgallery.com

Amicus Gallery
20 Pleasant St., Chester
Tel: (902) 275-2496
amicusgallery@ns.sympatico.ca
www.amicusgallery.ca

Anderson
160 Montague St., Lunenburg
Tel: (902) 640-3400
mail@andersonmontague.com
www.andersonmontague.com

Arctic Inuit Art
Judith Varney Burch
86 Mosher Rd., Kingsburg
Tel: (902) 766-4888 or (888) 766-0777
judithvarneyburch@gmail.com
www.arcticinuitart.com

**Art Gallery of
Nova Scotia West**
3411 Main St., Yarmouth
Tel: (902) 749-2248

**At the Sign of the Whale Nova
Scotia Crafts & Art Gallery**
543 Hwy #1, Yarmouth
Tel: (902) 742-8895
www.signofthewhaleonline.com

**Beales' Bailiwick Limited
John Beale**
124 Peggy's Point Rd., Peggy's Cove
shop@beales.ns.ca
www.beales.ns.ca

Black Duck Gallery
8 Pelham St., Lunenburg
Tel: (902) 634-3190
ducks@blackduck.ca
www.blackduck.ca

**Christopher Webb
Art Gallery & Studio**
106 Prospect Bay Road, Prospect Bay
Tel: (902) 852-4432
christopher@cwebb.ca
www.cwebb.ca

**Coastal Queens
Crafts and Gallery**
8100 Hwy 103, Port Mouton, Queen's
County
Tel: (902) 947-3140

**Cove Gallery and Pottery
Brenda and James Darley**
20 Irwin Hubley Rd., Seabright
Tel: (902) 823-2936
covegallery@eastlink.ca
www.covegallery.ca

Houston North Gallery
110 Montague St., Lunenburg
Phone: (902) 634-8869 or
(866) 634-8869
inuit@houston-north-gallery.ns.ca
www.houston-north-gallery.ns.ca

Jo Beale Gallery
154 Peggy's Point Rd., Peggy's Cove
Tel: (902) 823-1960
shop@beales.ns.ca
www.jobealegallery.net

La Maison d'Art
6785 St. Margaret's Bay Rd., Head of St.
Margaret's Bay
Tel: (902) 820-3033
pafrayn@eastlink.ca
www.lamaisondart.ca

Lunenburg Art Gallery
79–81 Pelham St., Lunenburg
Tel: (902) 640-4044
www.lunenburgartgallery.com

**Maritime Painted
Saltbox Fine Art Gallery
Tom Alway and Peter Blais**
265 Petite Rivière Rd., Petite Rivière
Tel: (902) 693-1544
saltbox@eastlink.ca
www.paintedsaltbox.com

Marlien Suermondt
180 Noonan Dr., Prospect
Tel: (902) 852-3868
marsuer@hotmail.com
www.marlien.com

Moxie. The gallery
619 Main St., Mahone Bay
Tel: (902) 527 1668
info@moxiethegallery.com

New Moon Studio
27 Hennigar Lane, RR #1, Bayswater
Tel: (902) 228-2972
boathousenorth@hotmail.com

**North Shore Canadian Art
Lunenburg Opera House**
290 Lincoln St., Lunenburg
Tel: (902) 634-1903
gallery@northshorecanadianart.com
www.northshorecanadianart.com

**Northern Sun Gallery & Gifts
Lynne Lawrence**
8 Edgewater St., Mahone Bay
Tel: (902) 531-3000
northernsun@eastlink.ca

**Out of Hand
Marja Moed**
135 Montague St., Lunenburg
Tel: (902) 634-3499
oohlunenburg@gmail.com

**Peer Gallery
Susan Hudson**
167 Lincoln St., Lunenburg
Tel: (902) 640-3131
shudson01@bwr.eastlink.ca
www.peer-gallery.com

**Pentz Pottery & Gallery
Louise and Don Pentz**
190 Pentz Rd., RR #1, Pleasantville
Tel: (902) 688-2732
louise@pentzgallery.ns.ca
www.pentzgallery.ns.ca

Peter Gough Studio
80 Tanner Frederick Rd., Glen Haven
Tel: (902) 821-2017
petergough@eastlink.ca
www.petergough.ca

**Savage Gallery
Roger Savage**
611 Shore Rd., Mersey Point, Liverpool
Tel/Fax: (902) 354-5431
info@savagegallery.ca
www.savagegallery.ca

Fine Art Galleries in Nova Scotia

**Shelton House
Studio and Gallery
Carol Ann Shelton**

572 Main St., Mahone Bay
Tel: (902) 624-0174
carolshelton@auracom.com

**Spirit Song Gallery
Carol Whitcombe**

341 Main St., Mahone Bay
Tel: (902) 624-8299
carol.whitcombe@ns.sympatico.ca

**The Moorings Gallery
Doreen Valverde**

575 Main St., Mahone Bay
Tel: (902) 624-6208
info@mooringsgallery.com
www.mooringsgallery.com

**Third Eye Gallery
Photography by Mary Dixon**

4058 Hwy 325, Newcombville,
Lunenburg County
mary@marydixon.com
www.thirdeyegallery.ca

**TREES Gallery
Lynn Feasey**

Tel: (902) 531-8733
trees@treesgallery.com
www.treesgallery.com

Valverde Studio/Gallery

31 King St., Chester
Tel: (902) 275-5341
jvalverde@ns.sympatico.ca
www.valverdestudiogallery.com

Yarmouth Waterfront Gallery

90 Water St., Yarmouth
Tel: (902) 742-7089